Giorgio de Chirico

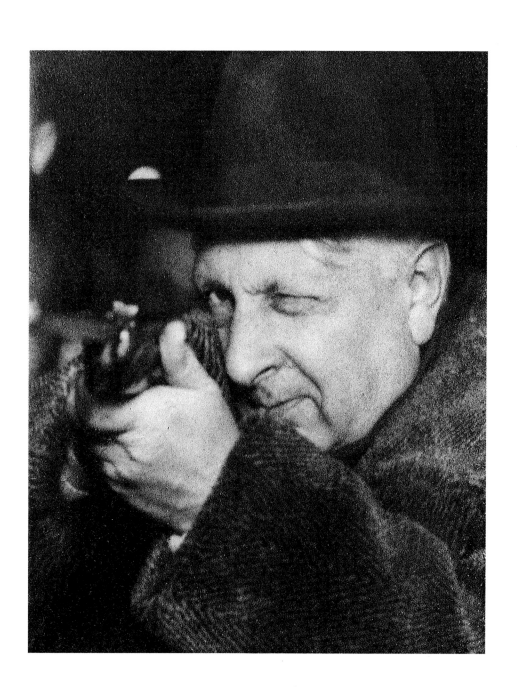

PERE GIMFERRER

DE CHIRICO

ACADEMY EDITIONS · LONDON

The exactitude of some of the dates is placed in doubt by the
historical research of scholars and art critics. The indications
given in this volume adhere to the principle of respecting
the dates written by the artist on his canvases or otherwise
declared by him.

Photographic credits:
Aldo Cimaglia, Carmelo Guadagno, David Heald, Walter Mori,
Takashi Okamura, Pagani, Alessandra Pedonesi, Giuseppe
Schiavinotto.

First published in Great Britain in 1989 by
ACADEMY EDITIONS
7 Holland Street, London W8

ISBN 0-85670-991-3

© 1988 *Ediciones Polígrafa, S.A.*
Translation by Anthony Curran
Reproductions rights S.I.A.E., Roma – S.G.A.E., Madrid
Printed and bound in Spain

La Polígrafa, S.A., Parets del Vallès (Barcelona)
Dep. Leg.: B. 5.148-1989

Giorgio de Chirico

The case of Giorgio de Chirico is probably unique in the history of contemporary art. There can be few artists who are as universally famous yet, at the same time, so little known. Anyone with a minimum of education will have seen at least some of his "metaphysical paintings," if only in photographic reproduction, and will be able to recognize them. Considering this universal fame, however, relatively few people are fully aware of de Chirico's development. His metaphysical painting — in the strict application of this term, the painting up to 1919 — won him an early, definite, irrevocable celebrity, comparable to that of Picasso in the blue and pink periods and Miró in that of his *Constellations*. Like them, he is part of the panoply without which today's observer cannot conceive of modernity. In 1919, de Chirico had just turned 30; he was to go on painting without interruption almost until his death in 1978. To confirm the hypothesis of the unity of his work — essential in any artistic exegesis — we must examine all his activity as a whole.

Let us begin by pointing out clearly the root of the problem, in the full knowledge that the root is one thing, and its ultimate ramifications another. The story, however well known, calls for a brief résumé here. The young de Chirico settled in Paris and, after a period of searching influenced by Böcklin, created metaphysical painting, which can be dated from 1910 and is, in its way, just as radical a renovation as cubism, anticipating the much later painting of the surrealists. Metaphysical painting is characterized by the absence of the human figure, at least of the animate human figure, though it may exceptionally appear asleep or motionless in the distance. It is replaced by the tailor's dummy and by the association of unexpected objects in a scene that, while dreamlike, is apparently painted with topographic and perspective detail. (Often, the perspective is illusory and closer analysis shows it to be as unreal as the scenes depicted.) Metaphysical painting was early admired by Apollinaire and shortly afterward hailed by André Breton on behalf of the surrealists. It is difficult, indeed, to imagine most surrealist painting without de Chirico, as he had a decisive influence on artists such as Salvador Dalí, Max Ernst, Yves Tanguy, René Magritte and Paul Delvaux, to name but a few.

It must be made clear, however — because here perhaps lies the germ of many later misunderstandings — that what for these younger artists was merely part of the vanguard, part of what Octavio Paz was later aptly to call "the tradition of rupture," was for de Chirico a completely personal experience. It was also the result of philosophical training — centered on Nietzsche and Schopenhauer among others — quite different from the literary training, centered on French symbolism, which later characterized the surrealists. Similarly, when Tristan Tzara founded Dada in the Cabaret Voltaire in Zurich, de Chirico had already produced a great number of masterpieces of metaphysical painting; thus it should not surprise us that when the surrealist painters began to gather the legacy of de Chirico the metaphysician, the latter was turning toward other centers of interest in his painting. After a few ambiguous years of transition, the break was finally made: the surrealists do not accept de Chirico's painting after 1919 and de Chirico reacts by rejecting the surrealists in an increasingly forthright manner, without in any way repudiating his own metaphysical work. He would return to its themes, along with others, at intervals until his death.

Until very recently the critics have left the conflict couched in the terms of the twenties, after the break between de Chirico and André Breton. It was undoubtedly a question of two strong personalities and after the break little more could be expected than a widening of the gulf. Indeed, the evolution of the writings of de Chirico — which were very numerous and of great literary and historical value — shows a tendency to provocative exasperation; he answers Breton in an increasingly cutting and disdainful way, even, in an attitude very different from that of the young de Chirico, almost denying any value to most painting after Cézanne, with few exceptions like Picasso and Derain. Parallel to this, de Chirico's painting makes incursions into the most diverse fields, without giving up metaphysical painting. Again, the attitude of the detractors of the post-1919 de Chirico is not so homogeneous and free of cracks as might at first appear, despite the important repercussions it had until quite recently on museum circles.

Marcel Duchamp in his time declared that posterity's judgment might differ from that of the people who had rejected de Chirico's post-1919 work. In a supreme paradox, those who denied the value of de Chirico's painting in the twenties were forced to recognize his novel *Hebdomeros*, published in 1929, as a masterpiece of literary surrealism. In those years, de Chirico's most recent painting was analyzed by Jean Cocteau, doubtless a writer far-removed from strict surrealism but by no means alien to the avant-garde. In Italy in the mid-thirties, a writer like Carlo Emilio Gadda, who can hardly be considered aesthetically stagnant, expressed his admiration for de Chirico. Magritte's fidelity to de Chirico is well-known and would be sufficient alone, or with Duchamp's words, to demonstrate that even in the surrealist camp there were exceptions.

Such battles need not be fought today. However much we may owe to the surrealist attitude, our problem today is not what the surrealists thought of a work, but rather what that work means. Generally, critics of the mature de Chirico have omitted one point aptly made by André Bazin with reference to another controversial work — Chaplin's filmmaking after *Monsieur Verdoux* (1947). According to Bazin, after a certain measure of recognized achievement — and there can be no doubt that the early Chaplin and the metaphysical de Chirico achieved this handsomely — all subsequent artistic work by the same author should enjoy the benefit of the doubt, even, where necessary, to the point of a suspension of judgement, provisionally considering apparent defects as virtues that we do not yet know how to appreciate. Some detractors of de Chirico's development have been more explicit with precise reasons for their rejection, but none of them ever thought of adopting Bazin's position. Far from being eccentric, this concept underlay an absolutely decisive stage in cinematographic criticism, appearing in the pages of *Cahiers du cinema* for people who were later to be the filmmakers of the *nouvelle vague*.

This is now the time to consider what is peculiar about the development of Giorgio de Chirico. We have said that his case is unique in contemporary art. It is unique, above all, in that it is still an unresolved case, on the way to gradual resolution only in very recent years, after de Chirico's death; unique, too, in that problems which usually affect different artists separately all converge in de Chirico. There are figures of the first magnitude in other arts, of whom the critics have at first only accepted the early period: witness the cases of Fritz Lang in the cinema and Góngora in literature, both, however, long since resolved. There have been similar cases in the painting of our century: we need only think of Picabia and Dalí. There have been cases of authors whose work has caused controversy over authentication — Dalí is a clear example — and those (more common than is generally thought)

who have treated the same theme with very similar iconographic solutions at different periods, as we observe in Munch or Magritte.

Two of the most controversial aspects of de Chirico's activity also have clear parallels. The transition from metaphysical painting to the post-1919 classical style might recall Dalí, but though there may be some point of contact, the similarity is basically misleading. For Dalí, it is a question of an irreversible evolution which, moreover, sets out from a much more traditional base than that of the metaphysical de Chirico, while de Chirico starts with a profound innovation to which he does not hesitate to return when necessary. It would be more pertinent, perhaps, to establish the parallel with the Magritte of the "Renoir period," which does not exclude a return to the dreamlike Magritte or even, strictly speaking, the intersection between the surreal and the technique à la Renoir.

What has brought de Chirico most reproach — the ambiguous or deliberately false dating of works — while it has admittedly caused complex problems of cataloguing, at least has a counterpart of the first order in the contemporary avant-garde. The work of the greatest Catalan poet of our century, J. V. Foix, brings together under the general title *Diari 1918* an extensive series of poems and prose published in book form between 1927 and 1972. However, it is believed that only a small part of these poems — perhaps none of them in their present form — can have been written in 1918. Another essential book of Foix's, the volume of 70 sonnets entitled *Sol i de dol*, appeared in a private edition in 1947 with the date 1936 printed on it. If it is true that it was written and ready for printing in 1936 and that in the forties the practice of antedating to before the war was a common way of getting round the *franquista* censorship of publications in Catalan, it is no less true that in 1947 non-clandestine books were already appearing in that language and that the last ten sonnets were in all probability written after the war. One can apply to Foix Augusta Monferini's comment on the problems of dating de Chirico: "In putting a dreamed-up date, the Great Metaphysical was claiming it as an act of liberty and of nonconformity to the norms."

All the controversial features that appear in de Chirico can be found separately in other notable artistic figures, but with de Chirico they are all found together; the deliberate provocation present in both de Chirico's writings and his painting can only have emphasized the controversial potential of his attitude.

One last point should also be taken into account, by virtue of its double significance. The metaphysical de Chirico adulated by the critics had no success with the public at the time and this explains, to a large extent, why he is found more often in museums. By contrast, the post-1919 de Chirico, debated and rejected by the critics, was always liked by the public and is found above all in private collections. So the vicious circle closes. The later pieces are increasingly difficult to see and even, at times, to photograph, and this inevitably puts back the general, global judgment of a work already dispersed throughout various countries and continents, from Stockholm to Rome and from New York to Mexico City. In recent years, an intelligent exhibition policy and the advent of critics, students and gallery owners and visitors not conditioned by historic disputes have opened up the way, posthumously and perhaps for the first time, for a comprehensive evaluation of Giorgio de Chirico.

De Chirico's artistic experience centers around two crucial moments: the discovery of metaphysical painting in 1910 and of classical painting in 1919. Both episodes have been

related by de Chirico himself, and even supposing that, for the sake of synthesis, he allowed himself to summarize graphically in a single scene the various nuances of an evolution, there is no reason not to believe that his narration is truthful in the sense that matters most to us; there was, doubtless, a moment in which he suddenly became disturbingly conscious of a reality that had been accumulating inside him without his realizing it.

About the beginnings of metaphysical painting, Giorgio de Chirico writes in his *Memorie della mia vita:* "I sometimes painted small-scale paintings: the Böcklin period was already over, and I had begun to paint matters in which I tried to express the strong, mysterious feeling I had discovered in the books of Nietzsche: the melancholy of beautiful autumn afternoons in Italian cities." He gives more detail in a manuscript written in 1912:

Allow me to relate how I had the revelation of a painting which I will present this year at the Salon d'Automne called Enigma of an Autumn Afternoon. *On a clear autumn afternoon I was sitting on a bench in the centre of Santa Croce square in Florence. Of course, it wasn't the first time that I had seen that square. But I had just got over a long, painful intestinal upset and I was in a state of morbid sensibility. All around me, even the marble of the buildings and the fountains seemed to be convalescent. In the centre of the square stands the statue of Dante, dressed in a long tunic, with his books close to his side and the laurel-crowned head inclined pensively. The warm, strong autumnal sun lit up the statue and the front of the church. I then had the strange impression of looking at those things for the first time and the composition of the painting revealed itself to my mind's eye.*

Seeing the unusual in the everyday, or simply seeing the everyday for the first time, is to rediscover the sacred in the everyday: from cave painting to surrealism, by way of Romanesque, extends a line of perception of reality that is invisible to visible reality. Novalis was hinting at this when he spoke of giving "everyday realities a mysterious aspect, known objects the dignity of the unknown." Before the surrealists were to explore this ground, Giorgio de Chirico had already fully conquered it for himself in his metaphysical painting.

The artist's second revelation took place in Rome in 1919. "It was in the Villa Borghese Museum, one morning, in front of a painting by Titian," he writes in his *Memorie della mia vita,* "when I had the revelation of a great painting." One can ignore the poetic hyperbole, both serious and ironic, of what follows — a Pentecost of tongues of fire, extraterrestrial sounds and resurrection trumpets — but one must read the following paragraph carefully:

I realized something enormous was happening. Up to now, I had looked at paintings of the masters in the museums of Italy, France and Germany and I had always seen them as everybody sees them: in other words, I had seen them as "painted images." Naturally, what was then revealed to me in the Villa Borghese Museum was only a beginning; since then, by dint of study, work, observation and meditation I have made gigantic steps forward...

Here, the narrative takes a new turn toward satirical hyperbole, in a feint typical of de Chirico the polemicist and memoire-writer, but something very important has been said in the meantime. In the same way that the essence of the metaphysical de Chirico is the act of seeing everyday things as if for the first time, so the essence of the neoclassical de Chirico lies in his ceasing to view the paintings of the old masters as "painted images."

De Chirico does not tell us explicitly what he then sees, but the answer is evident: he sees the painting.

This is a good point at which to pause. In the first phase, when he discovers metaphysical painting, de Chirico discovers what is, in a way, the essence of art: the possibility of seeing things as though for the first time, an experience that can only be formalized by the very operation of creating the work of art. This is a different way of knowing from that of ordinary perception, and it will only exist in tangible form in the work itself. The stroke of genius — and one must speak of genius — is that de Chirico discovers for himself a new form of stimulating this knowledge through painting. A discovery like that of metaphysical painting is of necessity irrepeatable; once made, it opens the way for other painters. The revelation of 1919 was of another kind. Like the majority of observers (sometimes, even painters) de Chirico saw old paintings as "painted images" only. Soon, he progressed to seeing them as painting. This is a strictly individual discovery and can, therefore, be repeated by another artist in his own way. It is not the essence of art that de Chirico discovers here — he had already discovered that — but the specific nature of pictorial art. From now on he will admire the old paintings not because their iconography attracts him, but because their painting seduces him; likewise, he will tend to reproduce this, even when he goes back to metaphysical themes. It is quite evident that certain of his reworkings of metaphysical subjects done after 1919 are technically superior to some original paintings on the same theme.

Here it would be as well to listen to the various arguments that could be brought into the debate. The aforementioned technical superiority could be deemed inferiority by some, to the extent that the finish of the pieces of the strictly metaphysical period was more innovative, being less tributary to the classical tradition. By the same logic, the discovery of classical painting and its restoration can be challenged as betraying a reactionary process, the opposite of what is observed in Picasso and Miró as regards the models of past art. Such, in fact, has been the main argument of the detractors of de Chirico who have preferred not to follow the strict arguments of André Breton's surrealism but to invoke the general evolution of art. This argument — apart from the fact that it is very debatable whether the analogy with Picasso and Miró can be mechanically applied — has at least two weak points, one theoretical and the other historical. Theoretically it introduces, almost imperceptibly, the notion of chronological progress into the world of art. Such a thing is contrary to the most elementary principles of aesthetics, as the experience of the past shows us; each time a movement (Romanesque, Gothic or baroque) has been condemned in the name of the progress of art, it has later been rehabilitated. The notion of lineal progress in art is an illusion. Neither can we scorn the historical argument, which a comparative study of the various artistic disciplines provides in a simple, direct way. Seduction by classical art and a desire to rework it by no means occurs only in the field of painting or concerns only de Chirico. Quite the contrary: since the twenties it has been a current that has become broader and more important the greater the number of founders of the avant-garde among its adherents. Reference to other painters would be easy but, perhaps, examples from the other arts would be more illuminating. The attitude of Stravinsky when, after the *Rites of Spring* (1913), he follows Pergolesi in *Pulcinella* (1920) or more generically aspires to an Olympian classicism in *Oedipus Rex* (1927) or *Apollo Leader of the Muses* (1928), is clearly no different; with de Chirico, these works can only be accurately and fruitfully captured in a dual dialogue, with the classical models on the one hand and with the author's previous production on the other. The reference to Pergolesi and the previous existence of the *Rites of Spring* (and also, in the other direction, of the later [1927] *Threni*) together

give *Pulcinella* its full significance. In the same way, when de Chirico imitates Watteau, Rubens, Fragonard, or Tintoretto (as in *The Fall* of 1947) or when he adopts classical motifs (gladiators, still lifes, horses) or crosses them with metaphysical motifs, a double operation is performed which cannot but disturb us, since we are not insensitive to the double paradox inherent in the fact that the painter is a man of today and not just any man of today but precisely Giorgio de Chirico. Similarly, a great part of the fascination — and the avant-garde character — of a film like Alain Resnais's *Mélo* (1986) derives from the respectful, strict filming of a traditional text by Henri Bataille from the boulevard theatre of the twenties, done by a filmmaker who had previously worked on the most daring experiments in montage using radically innovatory scripts.

A literary case could serve as a good example: the rediscovery of Góngora. Góngora is, without any doubt, the greatest verse artist in the history of the Spanish language. After being condemned as baroque in the name of good taste at the beginning of the eighteenth century, he began to be invoked at the end of the nineteenth century by Verlaine and Rubén Darío, though his apotheosis came on the four-hundredth anniversary of his death, in 1927. The most notable material expression of his rehabilitation was a monogaphic issue of the review *Litoral* in homage to him with contributions by, among others, Juan Gris, Picasso, Dalí, Manuel de Falla, Federico García Lorca, Rafael Alberti and Vicente Aleixandre. (I am a withness, moreover, of how even in November 1975 Joan Miró read Góngora every morning before setting to work.) It is clear that from the very start many of those just quoted were attracted to Góngora precisely for the reasons that appeared to separate him from classical taste, that is, precisely because he seemed to be an avant-garde poet. But the fundamental, philological operation carried out since that year by Dámaso Alonso leaves no doubt about Góngora's classical roots: classical poet he was, though badly read by classical tastes. This essential ambiguity was to nourish the Góngora-inspired poetry of Alberti. To a certain extent, discovering Góngora is to discover the classics; thus, when Ungaretti, in his *Da Góngora e da Mallarmé*, translates one of Góngora's most famous sonnets, the one that begins "Mientras por competir con tu cabello..." (While to compete with your hair...) he is merely giving back to the Italian language and literary tradition a text that proceeded from them, since Góngora's sonnet is, in turn, a free imitation of a sonnet by Bernardo Tasso.

An operation that is licit in music, cinema and poetry — indeed, not only licit but manifestly fruitful — could hardly be illicit in painting. It is clear that the operation itself is one thing (although frequently the discussions have not gone beyond this question of principle) and its aesthetic results in specific works another. De Chirico could, for example, put all his boundless energy, his stunning intelligence and his scant technical knowledge into painting in the manner of Rubens, just as Alberti could put them into writing in the manner of Góngora. But, by definition, just as Alberti could not write exactly the same as Góngora, de Chirico could not paint exactly the same as Rubens, and for two powerful reasons: he did not live in the seventeenth but in the twentieth century, and he was not Peter Paul Rubens, nor even a contemporary disciple, but Giorgio de Chirico, a painter of such a clearly marked personality that he could not fit himself into the Rubens mold. Furthermore, it is evident that both de Chirico himself and those who saw his painting were conscious of this. Any examination of de Chirico's evolution must take this circumstance into account: the post-1919 de Chirico aspires to paint like the old masters in the full knowledge — there is no artist more conscious of what he is doing — that he can come close to this but not achieve it entirely, because both the time in which he lives and his own too clearly marked personality

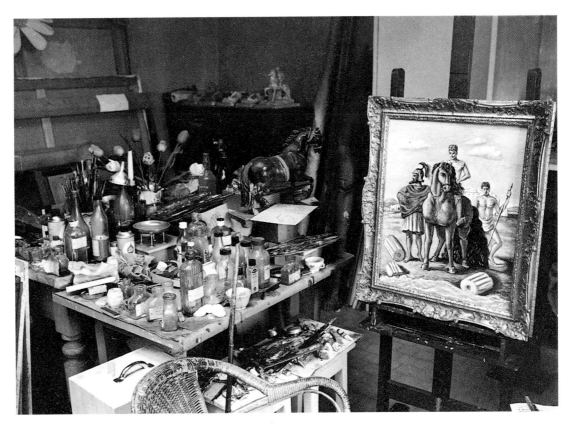

Detail of the artist's studio.
(Photo: Ermete Marzoni, courtesy of Isa de Chirico).

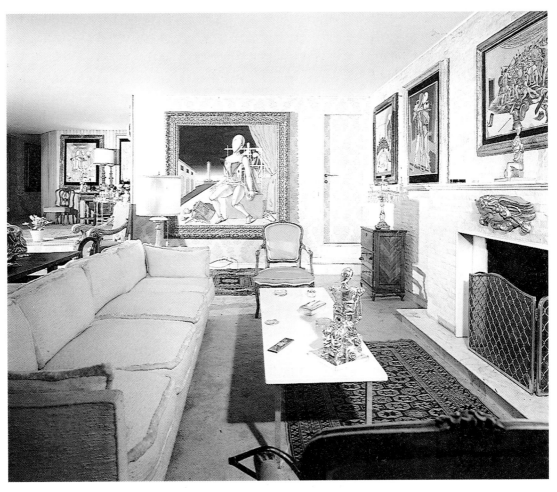

Detail of a sitting-room in the artist's residence.
(Photo: Walter Mori).

prevent it. De Chirico may be a good copier (even of himself), but only in the sense that Rubens himself could be a great copier of Titian, producing, over the imitation of the previous model, a canvas that almost imperceptibly becomes a work in its own right.

The forgoing line can be taken as an oblique hint of the dicussion concerning de Chirico which I will go out of my way to consider, preferring to examine polemics one by one rather than take refuge in the limbo of omitting them deliberately, since the polemics explain quite a lot about the evolution of the artist who took an active part in them. It has been said, or suggested, that such a purely neomannerist or late baroque style as appears in certain works by de Chirico could not, in the present context, have avoided finishing up in the ambiguous terrain of kitsch. While I accept that, I wonder if there is anyone who seriously thinks that the artist himself had not considered this. I am not the first to point out, from a perspective favorable to de Chirico, that part of the fascination of his late work derives precisely from the fact that it constitutes a conscious exploration in the domains of kitsch which, in short, are those of the postmodern period. Such a painting as *Island with Garland of Flowers* (1969; Fig. 117) cannot be read otherwise, being both undeniably beautiful and undeniably kitsch, in the same way that the film images of Rainer Werner Fassbinder and those of his master, Douglas Sirk, are deliberately beautiful and kitsch.

It seems opportune here to recall, both by way of a corollary to what has been said and an introduction to what is to follow, a very acute observation by Maurizio Fagiolo dell'Arco:

De Chirico is a classical painter. Not because he claimed this in the distant post-war return to order ("Pictor classicus sum",) but because one must look at a painting of his (and, therefore, study it) as one analyzes a Caravaggio or a Botticelli. A painting of his is not a serial object but an active subject which is related to others and acquires its real value thanks to the historic relation. The ideal student of de Chirico should, therefore, have the required methodology (discerning eye, iconology, psychology of form, historical knowledge) we require of a historian of classical art.

Nothing could be more appropriate: no painting by de Chirico ends with itself and all are interlinked — as Franciscos Rico has said of poetry — "in a tie-up of memory and history and history and memory." The work of de Chirico sets up a dialogue with itself and with the pieces that we admire in the museums in which the art of long ago is kept.

One might believe at first that the feeling of strangeness, of unknown territory — *terra incognita*, as it was called on the old planispheres where unexplored land was reached — this belonging to nowhere, the total *dépaysement* (exile) that intrigues us in de Chirico springs, above all, from the invention of metaphysical painting. But it is no less certain that we find it too in the post-1919 de Chirico and that, without any doubt, it proceeds from the fact that he is a modern painter for whom the ancient canons apply; not just the external, more visible ones, but also those of iconography and composition, to such an extent that, for any observer familiar with it, the whole work of de Chirico constitutes a true imaginary museum of his essential iconic repertoire. Each piece finds an echo in the others and is in turn an echo of them. And it is precisely in this way that one should read the metaphysical de Chirico, if one is to read him justly, with the only difference that the sign repertory does not proceed here from the museum but from a code established by the artist himself. From the moment of its inception, however, this code acts exactly like a classical canon. As far as we are concerned here, both a theme inspired by Ariosto, in the style of Angelica

Freed by Ruggiero, or a theme of distinct metaphysical coinage — like *Il Trovatore* — are, each time they are re-elaborated, part of a vast common archive; so it need not surprise us if classical motifs like the Dioscuri, Orestes and Pilades, or Hector and Andromache form part of metaphysical painting. Even, perhaps, its most characteristic motif, the one which inspired its genesis — the Piazza d'Italia, in its different variants — cannot but remind us of the deserted square and the empty buildings, as in an architect's sketch, which appear in one of Botticelli's late masterpieces, *The Miracles of San Zenobio*, painted about 1500. However, we should not forget that neither Italian architecture nor renaissance painting, contrary to appearances, is a direct source of inspiration to the metaphysical de Chirico. Here, as on so many other occasions, de Chirico has told the strict truth about the circumstances of the origin of his paintings, centered on the metaphysics of the squares of Italian cities. Even a student like Rubin, critical of the post-1919 de Chirico, has proved that the apparent renaissance debt of these architectonic perspectives is deceptive, belied by a subtle transgression of logical optical laws.

Essentially de Chirico is indeed a classical painter, not because he wanted to duplicate the external aspect of classical painting (something he desired at times and at times achieved, but that is another matter), but because his attitude to the iconic motifs available to him is that of a classical painter to the materials that tradition provides. However, de Chirico cannot avoid being a modern painter and, what is more, one of the founders of modern painting. Perhaps this is the most appropriate angle of vision from which to examine an area of his work that has given rise to perplexity: the different versions, sometimes of uncertain date, of a same painting. I am not here alluding to reworkings of the same theme, however similar, or to the creation of new paintings through the combination of elements from his own earlier work, for there are numerous examples of both in contemporary art, and I have myself had the opportunity of studying the process at length in the case of Miró. No, what I am here alluding to is the exact copy, done not once but several times, of *The Disturbing Muses, Piazza d'Italia* and other famous paintings. Because he was a classical painter, de Chirico could not avoid proceeding in his own work as a classical painter, producing a new copy if it was ordered exactly the same as El Greco, or at least his studio, had done when receiving orders for a *Penitent Magdalene* or a *Christ Hanging from the Cross*, for example. But as a modern painter, and even a postmodern painter, de Chirico could not help feeling attracted by the game of ambiguity and freely dating (perhaps antedating) a work.

One of the last films by Orson Welles, *F for Fake* (1973) analyzed — through, among other people, the art forger Elmyr de Hory — the typically postmodern and the nascent fascination for what lies in the imprecise territory between the authentic work and the forgery. This fascination now finds its ultimate expression in exhibitions of forged paintings, each with its certificate of authenticity as a forgery and with its quoted price on the forgeries market, side by side with that of authentic works. De Chirico always denounced forgeries, frequently with success in the law courts. In the opinion of Fagiolo dell'Arco, about thirty of them were the work of Oscar Domínguez, which, if it were confirmed, would be another interesting piece of information, as Domínguez is a notable painter. But de Chirico, precisely because he prosecuted forgers and refused to authenticate his pieces, had the right, not to falsify his own works — for, say what you will, an author by definition cannot forge himself —, but to paint them again, to create duplicates, something similar to what Fautrier would in his day know intuitively to be multiple originals. Thus the dialogue with the work itself and with the museum world is reproduced on a microscopic scale and extended to a dialogue

with the market, with the collection and also with students and writers. Every version of *The Disturbing Muses*, for example, through its mere existence, sets up a simultaneous dialogue with all these interlocutors and it is impossible not to see in it an attitude as clearly subversive as that which provoked Marcel Duchamp's activity after he gave up "retina painting."

Up to now, a general consideration of de Chirico's work has prevailed over an examination of this or that work in particular. It could not but be so in so unitary an artist. True, de Chirico's personality is very powerful and a single painting of his can never leave us indifferent, but the proper appreciation of the meaning of his work requires it to be contemplated in an overall panorama. Let us concentrate, for example, on one of the rightly most famous paintings of the metaphysical stage: *The Child's Brain* (1914; Fig. 21). The iconography of this work left visible traces on Max Ernst and, as Rubin has proved, even on Picasso; on the other hand, in de Chirico himself it is continued in two other oil paintings of 1914: *Portrait of Guillaume Apollinaire* (Fig. 20) and *Poet's Nostalgia* and in two later paintings *The Poet Philosopher* (1918) and *The Philosopher* (1924.) It is the later iconographic development which allows us to see the meaning of the piece more clearly, or at least de Chirico's own evolution regarding the motif treated, which was at first very ambiguous. However, if we see the painting only as an isolated work, its fascination is as undeniable as, and arises partially from, its obscurity, because the scene in itself is not susceptible to exegesis and cannot be translated into any language other than the pictorial. The only possible clue, apart from the very plastic existence of the work, could be that given in the title, but the title itself appears to have been a pitfall, because I have so far been unable to find an explanation of it in all the abundant bibliography on de Chirico. However, the origin of the title seems obvious to me and the only doubt I have is whether it was initially used by de Chirico himself or André Breton, who later became the owner of the painting and kept it in his possession for some time. In any case, either could have been the inventor, since I believe that it is undeniable that it proceeds from a text known to both of them: "Le Bateau Ivre" (The Drunken Boat) by Rimbaud, where in the third verse we read:

> *Dans les clapotements furieux des marées,*
> *Moi, l'autre hiver, plus sourd que les cerveaux d'enfants*
> *Je courus!*

> *(In the furious splashing of the tides,*
> *I, the other winter, deafer than the brains of infants*
> *I run!)*

That this is the source I have no doubt. But what does the sentence mean, either in the Rimbaud poem or in the de Chirico painting? For doubtless it has a precise meaning in both. What Rimbaud meant is not something that can easily be known — though it no doubt meant something very concrete — and matters little here. What does matter is what de Chirico could have thought, or what might have been thought in the milieu in which de Chirico then moved, about Rimbaud's intentions in a poem which everybody in the avant-garde Paris of 1913 knew by heart.

For any reader of Rimbaud it is impossible not to relate these verses with those which opened a poem of the same period, "Les Chercheuses de Poux" (The Nit Pickers):

Quand le front de l'enfant, plein de rouges tourmentes,
Implore l'essaim blanc des rêves indistincts...

(When the infant's brow, covered with red torments,
Implores the white swarm of vague dreams...)

That is, we find ourselves before the head of a child, infested by "red torments" (nits can simply be a metaphor, extension of reference to the stirring of the blood and fantasy, rather similar, if we must be so prosaic, to juvenile acne); against this "red" stirring, the child's head asks for the "white" help of dreams, another world of the absolute and of freedom — since it is a "swarm" and multiple and it is a matter of a plurality of "vague" dreams. Shut within this inner enclosure, the child's brain obviously has to be "deaf" to the outer world, and what Giorgio de Chirico's painting shows us is precisely the child's brain.

The idea, quite widespread at one time, that the masculine figure with bare torso and closed eyes that dominates the painting represents de Chirico's father seems to me not only debatable but also highly improbable. On the contrary, what must appear in the brain of a child thus conceived, according to Rimbaud's perspective which de Chirico adopts a his own, is the child itself converted into a clairvoyant. In dreams and fantasies, the child does not usually see himself as a child but as an adult, for the same reason that in his later fantasies the adult will frequently see himself as a child. With eyes closed — attribute of the clair-voyant — the philosopher, the poet, perhaps Apollinaire himself, and, of course, deaf to the outer world — which, moreover, is reduced to a fragment of sky and bits of metaphysical architecture, notable among which is what could be taken for a part of the "red tower" of the painting of that name of 1913, found in the Peggy Guggenheim collection in Venice — the clairvoyant, with his eyes closed, listens to his own world and clearly "reads" the closed book he has in front of him. Thus he connects with Baudelaire's conception, which is at the root of the symbolist adventure and of which Rimbaud, the metaphysical de Chirico and the surrealists themselves are the continuers:

Celui dont les pensers, comme des alouettes,
Vers les cieux le matin prennent un libre essor,
— Qui plane sur la vie, et comprend sans effort
La langage des fleurs et des choses muettes!

(He whose thoughts, like skylarks,
In the morning take free flight towards the heavens,
Who glides above life, and effortlessly understands
The language of flowers and mute things!)

as we read in "Elévation," the third poem of the 1861 edition of *Les Fleurs du Mal*. It is important to note that all of this was common currency for those interested: Rimbaud cannot have been ignorant of Baudelaire's poem, and de Chirico must necessarily have known, like anyone in the artistic circles in which he moved, both Baudelaire's poem and the two by Rimbaud, with the same certainty and naturalness with which a renaissance or baroque painter knew Ovid's *Metamorphoses*, one of the books that appear in an inventory of the belongings of Velázquez at his death.

The genius of the metaphysical de Chirico lies in his being the first artist to give a deliberate and systematic plastic form — not just an intuitive one like Le Douanier Rousseau did,

though the eventual degree of deliberation in Rousseau and his possible influence on de Chirico have both been debated — to the world of the clairvoyant. Others had represented symbols or emblems or figurations: this was the job of symbolist painting, and here we need only recall Gustave Moreau. But with the metaphysical de Chirico we are present for the first time not at a display of allusive vision, but at a world painted in accordance with the logic of the dream. Paraphrasing de Chirico's own words regarding his discovery of classical painting, other artists — this is valid for Gustave Moreau, Füssli or William Blake, even for Arcimboldo or Bosch — have given us very beautiful "painted images" of the dream; but it is only de Chirico who gives us the painting of the dream itself.

What has been said thus far naturally concerns what is usually called true metaphysical painting, that is, the period of de Chirico's work beginning in 1910 and ending approximately in 1919. But it would be blind fetishism, vain nominalism to continue denying evidence that it can also be applied both to the copies or reworkings of paintings of the metaphysical period, which rigorously respect its technical features, and to the works on the metaphysical theme painted with their own techniques in the painter's later periods — and which, in the seventies, border on the burlesque, the deliberate play of irony, metaphysics having been converted into a private arsenal of de Chirico's motifs — and even to quite a few non-metaphysical works in which there is, however obliquely, an unexpected association of elements referring back to the metaphysical period. Moreover, here the metaphysical is just one more element among those composing the picture; perhaps therefore it would be fitting to examine again the meaning of the global evolution of Giorgio de Chirico.

Characteristic of this work is the fact that nothing that appears in it is ever discarded definitively. The initial Böcklin period will take some time to reappear, but reappear it does in the end; the metaphysical painting, as we have seen, will be with de Chirico until the last pictures he paints. In this refusal to renounce anything, in this desire to be various, even many different painters, without giving up profoundly himself, it is impossible not to see the seal of the strong bond between de Chirico's art and modernity. In just the same way, Fernando Pessoa was able to be the futurist poet Alvaro de Campos, the dogmatic, agrarian moralist Alberto Caeiro, the neoclassical Ricardo Reis, and even Pessoa himself, with a different personality for all his persona. Thus, in de Chirico, the metaphysical is just one of his facets, and here we must once again recall J. V. Foix — author at once of neopopularist poems, of poems close in orbit to surrealism and of Petrarchan sonnets — for whom the different literary periods or trends held the strict consideration of literary genres. This attitude, coinciding with those of Pessoa or Stravinsky, for example, is clearly at the root of Giorgio de Chirico's development.

Having focused things in this way, it is easy to distinguish, if not the "at least twelve painters" that Fagiolo dell'Arco discerned in de Chirico, then some of the genres that de Chirico cultivated intermittently but without ever abandoning them, often with different pictorial techniques according to the period — corresponding, if you like, to each of the successive "twelve painters" — in which he adopted them. Thus, we have de Chirico the copyist, author of paintings "after" — copies of himself, but also of Rubens, Watteau, Fragonard, Rafael, Tintoretto —; de Chirico the portrait painter and with him de Chirico the self-portraitist; de Chirico, the painter of gladiators; de Chirico, the painter of horses, frequently in a classical landscape; de Chirico of cavalry, of Ariosto-style or medieval battles; the exotic or orientalist de Chirico in the mode of Delacroix or even Fortuny; de Chirico,

the painter of mythological scenes; de Chirico, the painter of still lifes, or, as he preferred to call them, "silent lifes," de Chirico, the painter of heroic deeds; de Chirico, the painter of the "mysterious baths"; de Chirico, the metaphysical painter; de Chirico, the neometaphysical painter. Each of the mentioned thematic categories — which do not exhaust the repertory — can occasionally combine with one of the others and all of them can be found, after 1919, under the palette of one of the various individual painters indicated by Fagiolo dell'Arco (classical, romantic, baroque-romantic, neometaphysical, among others) or of some painters deliberately not included in this enumeration but who are equally and unmistakably de Chirico. Now, was the ultimate sense of this operation merely eclecticism or a certain postmodern nonchalance? Of course not. Let us then try to discover the deeper meaning.

As a classical painter, de Chirico set out in the first place to *paint well* and to create *beautiful painting*. Painting well means, among other things, painting like a classical painter; but we have already seen that this is in itself impossible, so the concepts of *the well painted* and of *beautiful painting* here indicate tendencies. De Chirico can do an admirable copy of Raphael (for example, in *The Pregnant Woman* [1920; Fig. 37] or *The Dumb Woman)*, but the aesthetic functioning of his copy will be different, not from that of the original of Sanzio but from that of a copy of the period. De Chirico is the first to know that, in *The Fall (c.* 1947-54; Fig. 49), he does not limit himself to inspiration by Tintoretto, but, by inserting the turbulent truculence of mannerism into the iconography of the comic, he creates a disturbing autonomous pictorial object, equidistant from the baroque and the postmodern kitsch, whose many-sided interest in itself constitutes an investigatory critical operation, an incursion into the unknown; painting in the mannerist mode in 1947 is just as unusual an enterprise as reproducing metaphysical painting in 1910. De Chirico's motivations remained invariable throughout his long career. If one thing is certain, it is that he always wanted to create beauty and always wanted to paint like a classical painter. Even in a scene with dummies like *The Archeologists* (1927; Fig. 50) the confluence of the classical and the modern does not spring just from the fact that each dummy, sitting in his modern armchair, shelters classical ruins in his breast, but from the mannerist modelling of the left hand of the dummy on the right of the observer, who clearly separates his thumb from his index finger and both from the other fingers. Only a painter fascinated by mannerist art could have painted that hand, but only a painter of the most contemporary sort could have painted the non-faces of the dummies, summarizing in this motif the essential enigma of identity, the doubt over one's own being through the doubt over one's own face, which de Chirico starts in the metaphysical period and which was to leave a deep mark on Max Ernst.

What de Chirico displays before the hypothetical observer — who, unfortunately, has rarely seen a balanced representation of each stage and style of the painter — is a world of myths, of mythical beings: enigmas, gods, heroes, allegorical scenes. A repertory of beauty, which is all the more disturbing in that de Chirico never renounces the possibility of creating beauty in a form that we could call anachronistic. Indeed, all contemporary art is characterized by the desire to be other than contemporary, as when Picasso imitated Negro art or set out from Velázquez or Delacroix or Manet, or when Miró converted into ideograms the Dutch interiors which inspired him at a given moment, or when he evoked the evening tones of the master of his youth, the nineteenth-century Catalan painter Modest Urgell, whose paintings of dusk and cemeteries makes one think of the Italian poets of his time, the *creposcolari*. But perhaps only de Chirico comes to the classical painters intending to be

something else except that that "something else" means nothing other than being a painter like the classical painters. He goes much further into it than the impulse of neoclassical figurativeness of Tamara de Lempicka in the art déco framework: as far as he can he sets out to paint like Rubens, in the same way that Alberti set out to write like Góngora or Saint-John Perse like Babur, the Mongol king who conquered Samarkand. Or even more exactly: as Pierre Menard, created by Borges, proposed to re-write, word by word, Don Quixote — that is, to create an exact verbal duplicate of Cervantes' book, which would nevertheless be a work by Pierre Menard, conceived in the hard word-by-word process. Thus Giorgio de Chirico proposes, first, in the metaphysical period, to duplicate the interior world that lies beneath the visible world (what is glimpsed in the brain conceived by Rimbaud) and then, having returned to classical art, to create not something that merely resembles Rubens, for example, but something that functions aesthetically in the same way as a painting by Rubens. In this tantalising paradox — that of Pierre Menard, that of Borges, and that of Giorgio de Chirico — lies the Gordian knot of modern art and it is here that we get an inkling of how Giorgio de Chirico is never more modern than when he proclaims "Pictor classicus sum" at the height of the twenties. The invariable and often strange and obsessive beauty of his paintings is at the same time sensorial and mental: it owes nothing, in one sense, to preconceptions about what a painting today ought to be, but rather to the pure material seduction of the brushwork. On the other hand, it derives no small part of its fascination from the fact that the paintings, while so unlike in appearance, are the work of a single author and, while alternatively so modern and so anachronistic, are always the work of a modern and always the work of a classic.

The dialogue of de Chirico with himself and with all of the painting of the past can reach the most refined complexity, witness *The Master's Studio in Paris* (1934; Fig, 70). This painting refers at once to the Velázquez-style paradigm of *Las Meninas* and to the tradition of de Chirico, portrait and self-portrait painter as well as to de Chirico, the painter of horses and of mythological scenes, present in the painting which appears on the easel. The strange quality of *immobilized movement* in this canvas — even though, within it, the equestrian and mythological painting is in contrast vitally dynamic — situates us at one of the magnetic poles of de Chirico's iconography. Indeed, in all de Chirico's paintings — as in all the paintings of the classical painters, that is, those before the impressionists — something is always happening: but this something is either a paralyzed scene, a frozen movement (as in strictly metaphysical painting), or on the contrary, a changing scene, in constant, stormy metamorphosis, increasingly marked in proportion to how close the artist approaches the sphere of the neobaroque, which spreads even to the background landscapes.

It is the perfect unity and the unchanging beauty of this catalogue of motifs and emblems that ultimately makes us assent to Giorgio de Chirico's work, since the proof that affirms artistic creation as such can only lie in the fact that it imposes a plastic presence, which formerly did not form part of the world phenomena, as a necessary occurrence. Whether it be the classical simplicity of *Lucretia* — which, though it is a work of 1922, has not altogether forgotten the territories of the metaphysical, as one notes in the fragment of sky that appears in a corner or big tear almost traced with a set square, at the top right and maintains the same essential relationship with the central feminine figure as the central masculine figure does with the sky, here more explicitly metaphysical than in the same place in *The Child's Brain* — or whether it be in the enigmatic, hieratic quality of the metaphysical scenes or in the torment of colors in constant flutter of the neobaroque or Rubens period, this work reveals itself to us as something which, once placed on the canvas, necessarily

exists. Nor does it take us long to notice, provided we see canvases of his of different periods and distinct styles brought together and contrasted, that what we could call the "de Chirico effect" is produced precisely by the polyphonic conjunction of these different voices, each one of which is in a certain sense that of de Chirico without any of them separately being all Giorgio de Chirico, in a conception that is as renovatory for painting as the conception of the "polyphonic novel" that Mikhail Bakhtin has studied penetratingly in Dostoevsky with regard to the tradition of the monologue of the traditional narrator. Simultaneously or succesively, there are, indeed, many painters in Giorgio de Chirico, from the one who creates an entirely new language to the one who wants to reinvent the classical language. The supreme act of freedom that, from beginning to end, painting a picture has represented for de Chirico removes him both from the strict lists of the historical vanguard and from the coteries of those who imitate the classics to a greater or lesser extent. T. S. Eliot was right when he said that history may have been slavery, but may yet become freedom. Giorgio de Chirico found in history the same space for freedom as was revealed to him one sunny autumn afternoon in a Florentine square. What de Chirico offers us is not merely a succession of beautiful, disturbing canvases; it is the gallery of the history of painting in freedom.

<div align="right">

PERE GIMFERRER
Of the Real Academia Española

</div>

CHRONOLOGY

1888. Giorgio de Chirico was born on July 10 in Volos. His father was Evaristo de Chirico, a railway engineer of Sicilian origin, and his mother was Gemma Cervetto, native of Genova.

1891. His brother Andrea was born in Athens. In 1914 Andrea was to adopt the pseudonym Alberto Savinio (1891-1952). The de Chirico family returns to Volos and stays there until 1899. First drawing lessons.

1899. The family moves to Athens. Andrea studies music and Giorgio, having enrolled at the Polytechnic, studies drawing for four years and then follows a painting course under the portrait painter Jacobidis. In 1900 he paints his first painting.

1905. His father dies. His mother decides to leave Greece. A brief stay in Florence with visits to Venice and Milan in 1906.

1906. In the autumn they arrive in Munich. Giorgio frequents the Academy, discovers Böcklin and Klinger, studies Nietzsche, Schopenhauer, Weininger. His mother and his brother Andrea return to Milan, where the musical ambience is much more favorable for the latter. Giorgio remains in Munich until April 9, 1910 and paints his first recorded canvases, inspired by Böcklin.

1910. Andrea moves to Paris, while Giorgio meets up with his mother in Milan and then travels with her to Florence. The Böcklinian period has come to an end. In Giorgio's new paintings — the canvases of the *Enigmas* — the metaphysically inspired atmospheres of the future Italian squares first appear.

1911. Giorgio and his mother decide to join Andrea in Paris, where they arrive on July 14 after a brief stay in Turin. In the French capital they move house five times in a single year.

1912. Giorgio presents three canvases at the Salon d'Automne and, in 1913, following the advice of Guillaume Apollinaire, participates in the Salon des Indépendants. In November of the same year he exhibits again in the Salon d'Automne, where he sells his first painting, *The Red Tower*, to a client from Le Havre.

1914. He meets the young dealer Paul Guillaume, through Apollinaire, who has begun to follow his work with interest. He signs a contract with Paul Guillaume for the whole of his artistic production and exhibits once again at the Salon des Indépendants.

1915. The Firts World War breaks out. The Paris group disbands and the de Chirico brothers return to Italy where they join the army. Sent first to the district of Florence, they are then transferred to Ferrara, where their mother joins them. In Ferrara, Giorgio meets Filippo de Pisis and, through Soffici and Papini, Carlo Carrà. What was immediately to be defined as "metaphysical painting" was born, given theoretical credibility in the art journal *Valori Plastici* — to which de Chirico contributed from its very beginnings — as the literary mouthpiece of the "call to order" and re-dimensioning of the avant-garde.

1918. In the autumn of this year Giorgio manages to have himself transferred to Rome, where he lives with his mother amidst great financial difficulties. He collaborates with the *Valori Plastici*, futurist and Dada groups.

1919. First one-man exhibition at the Galleria Bragaglia in Rome. He sells only one painting. His works from the metaphysical Ferrara period are exhibited, and he publishes his *Noi Metafisici* (We Metaphysicals), a text of fundamental importance as the manifesto of Giorgio de Chirico's thought. Exclusive contract with Mario Broglio for his artistic and literary work.

1920-1921. De Chirico lives alternately in Rome, Florence and Milan, and participates in a series of important exhibitions, in which he shows metaphysical works and the results of his most recent research related to his assiduous visits to museums and the revelation of great painting (early 1919). His *Piazze Romane* are born.

1923. He lives in Rome and Florence, always in the company of his mother. In Florence he is the guest of Giorgio Castelfranco, his friend and mentor. He exhibits at the 1923 Rome Biennial, but the critics are unfavorable towards him.

1924. He participates in the fourteenth Venice Biennial. In Rome, where he is living with his mother and brother, he meets Raissa Gurievich Krol, a Russian ballerina from the "Theatre of the Eleven," who becomes his wife and travels with him to Paris, where she devotes herself to the study of archaeology.

1925. Giorgio and Raissa move to Paris, where de Chirico is recognised by the Surrealists as their master and inspiration. The Surrealists, clinging faithfully to his metaphysical painting, become an obstacle to the acceptance of his most recent work, which André Breton considers degenerate and does not hesitate to attack publicly on the occasion of Giorgio de Chirico's one-man exhibition at the Galerie Léonce Rosenberg, in May 1925.

1926. The rupture with the Surrealists becomes inevitable. De Chirico becomes in Breton's eyes a lost genius, while the genius himself becomes thoroughly inward-looking and adopts a severely anti-modern and anti-surrealist posture.

1927-1928. He begins to exhibit with the "Novecento" group both in Italy and other countries, and participates in exhibitions held in England and the United States. The critics begin to show an interest in his most recent work, about which Waldemar George writes a monograph in 1928. The same year — when open war with the Surrealists broke out — Jean Cocteau's "indirect study essay," *Le Mystère Laic*, was published, the first deep, poetical analysis of Giorgio de Chirico's work since the texts by Apollinaire and Breton.

1929. Giorgio de Chirico's extraordinary autobiographical text, *Hebdomeros*, was published (an "interminably beautiful work" according to L. Aragon). De Chirico creates the decor and costumes for the ballet *Le Bal* (The Ball) with music by Rieti and mise-en-scène by Diaghilev's Ballets Russes.

1930. He produces sixty-six lithographs for Apollinaire's *Calligrammes* (Éditions Gallimard). In Paris he meets Isabella Pakszwer, a Russian émigré, who was to be his second wife and with whom he was to live until his death.

1932. Giorgio and Isabella move to Italy, where he is forced to make several journeys because of his work as a scenographer and the several exhibitions he holds. Giorgio and Isabella return to Paris in 1934.

1935. De Chirico travels to New York where in the autumn an exhibition of his is opened at the Pierre Matisse Gallery. Praise from critics and public alike. Isabella joins him in 1936.

1938. Giorgio and Isabella return to Italy. In 1938 they are once again in France, but a year later they return to Italy and for two years live alternately in Milan and Florence. Giorgio exhibits in Turin, Milan, and Florence; he presents new naturalist motifs and several portraits. He begins to be interested in terracota sculpture.

1942. He participates in the Venice Biennial with a set of works that give occasion to the critics to speak of a "baroque" period characterised by the adoption of elements from the sixteenth and seventeenth centuries.

1944. The de Chiricos finally settle in Rome. Controversies around the painter's current research become the order of the day, research that forty years later would be the starting point for new painterly tendencies in Italy. Arguments arise as to the authenticity of his works, and these are to continue and become more bitter over the years.

1948. The Venice Biennial organises an exhibition giving precedence to Giorgio de Chirico's metaphysical period over and above his most recent work. He is nominated member of the Royal Society of British Artists, London.

1949. One-man exhibition of over one hundred works at the Royal Society of British Artists; these same works are then shown in Venice in opposition to those chosen for the Biennial.

1950. He organises an "antibiennial" with realist painters from the Società Canottieri Bucintore, Venice.

1952-1954. Individual exhibitions in Venice, conceived as anti-modern manifestations.

1955-1960. Intense activity with exhibitions in Venice, Genova, Rome, Turin and Milan. De Chirico openly goes back to metaphysical subjects of previous years. He continues painting "silent lifes" with landscape backgrounds, portraits and interiors, and is in constant conflict with contemporary art. He denounces the numerous forgeries that flood the market and works simultaneously on the different themes of his personal art panorama, independent of any tendencies or currents.

1964. He resumes his activities as a scenographer. At the end of the sixties he begins to produce sculptures in bronze, on which he has been working for some time. This allows him to present in three dimensions both the protagonists of his metaphysical world and his classical horses.

1968. The year which he began to work intensely with lithographs.

1970. Anthological exhibition at the Palazzo Reale, Milan. "I de Chirico di de Chirico," Palazzo dei Diamanti, Ferrara.

1972. Ibico Reggino Prize, Reggio Calabria. "I de Chirico di de Chirico," New York Cultural Center, New York.

1973-1974. Itinerant exhibition in Japan: "De Chirico presents de Chirico" (Municipal Museum of Modern Art of the Province of Kanagawa, Central Museum of Art of Tokyo, National Museum of Modern Art of Kyoto, and Museum of Art of the Province of Aichi).

1975. Exhibition at the Musée Marmottan, Paris, having been granted the title of Academic of France.

1976. He receives the Cross of the Great Officer of the Federal Republic of Germany.

1978. Artcurial, Paris: homage to de Chirico on his ninetieth birthday. November 20: Giorgio de Chirico dies in Rome.

1979. Artcurial, Paris: exhibition of the works from *The Artist's Studio*.

1980. Château-Musée, Cagnes-sur-Mer: *The Artist's Studio*.

1981. Galleria Nazionale d'Arte Moderna, Rome; Musée des Beaux-Arts André Malraux, Le Havre: *The Artist's Studio*.

1982. Museum of Modrn Art, New York; Tate Gallery, London; Kunsthaus, Munich. Itinerant exhibition of *The Artist's Studio* by invitation from the Seibu Museum of Art, Tokyo, in three Japanese cities (Tokyo, Nagoya and Osaka).

1983. Retrospective exhibition, Centre Georges Pompidou, Paris.

1984. Venice Biennial. *The Return of the Knight Errant*, Palazzo Centi Passi di Villongo, Bergamo.

1985. Palazzo Reale di Caserta. *The Master's Studio*, Palazzo dei Diamanti, Ferrara. *Late de Chirico*: itinerant exhibition in England organised by the Arnolfini Gallery, Bristol, then traveling to the Museum of Modern Art, Oxford, the Mappin Art Gallery, Sheffield, and the Dulwich Picture Gallery, London. Castel Mareccio, Bolzano. "De Chirico néo-baroque," exhibition at the Galerie Artcurial, Paris.

1986. The Fondazione Giorgio e Isa de Chirico is created in Rome. President: Isabella Far de Chirico; Vicepresident: Claudio Bruni Sakraishik, coordinator of the *Catalogo Generale delle Opere di Giorgio de Chirico*, publication of which began in 1971. Giorgio de Chirico's widow gave the foundation 10 oil paintings and 100 graphic works.
"De Chirico — Gli Anni Venti," Verona, exhibition subsidised by the Venice Region and the Fondazione Giorgio e Isa de Chirico, later transferred to the Palazzo Reale in Milan.

1987. Isabella Pakszwer de Chirico donation to the State of Italy: 24 works came to form part of the collections of the Galleria Nazionale d'Arte Moderna.

1988. Centenary of the artist's birth: retrospective organised by the Department of Culture of the City Hall of Venice, Correr Museum — Napoleonic Wing, subsidised by the Ministry of Culture and with the collaboration of the Galleria Nazionale d'Arte Moderna and the Fondazione Giorgio e Isa de Chirico, Rome.

BIBLIOGRAPHY

Alloway, Lawrence. "The Early Chirico." The London Gallery, *Art News and Review*, no. 6 (1949).

Apollonio, Umbro. "La pittura metafisica alla XXIV Biennale." *Le Arti Belle*, no. 14-15 (1948).

Bellonzi, Fortunato. *Giorgio de Chirico*. Rome: La Barcaccia Edizione, 1961.

Breddo, Gastone. "Giorgio de Chirico, pittore surrealista." *Lettere ed Arti*, no. 1 (September 1945).

Calvessi, Maurizio. *La metafisica schiarita*. Milan: Feltrinelli, 1983.

Carrieri, Raffaele. *Giorgio de Chirico*. Monografie d'Arte di Stile. Milan: Garzanti, 1842.

Ciranna, Alfonso. *Giorgio de Chirico*, Catalogue of graphic works (engravings and lithographies) 1921-1969, Milan and Rome, 1969.

Cocteau, Jean. *Essai de critique indirecte, Le Mystère Laïc - Des Beaux-Arts considérés comme un assassinat*. Paris: Édition des Quatre Chemins, 1928.

Conoscere de Chirico. Milan: A. Mondadori, 1979. With texts by Wieland Schmied, Alain Jouffroy, Maurizio Fagiolo Dell'Arco, Domenico Porzio. German edition, 1980; French edition, 1981.

De Chirico par de Chirico. Paris: Jacques Damase éditeur, 1978.

Dell'Arco, Maurizio Fagiolo. *Giorgio de Chirico. Il tempo di "Valori Plastici" 1918-1922*. Rome: Edizione De Luca, 1980.

Dell'Arco, Maurizio Fagiolo. *Poesie-Poèmes*. Rome: Studio S/Arte Contemporanea, 1981 (II volume, *Poesie-Poèmes* II, 1983).

Dell'Arco, Maurizio Fagiolo. *L'opera completa di de Chirico 1908-1924*. Milan: Rizzoli, 1984.

Dell'Arco, Maurizio Fagiolo. *Giorgio de Chirico: Il meccanismo del pensiero*. Turin: Einaudi, 1985.

Faldi, Italo. *Il primo de Chirico*. Venice: Alfieri, 1949.

Far, Isabella. *Giorgio de Chirico*. Rome: Edizione Bestetti, 1953.

Far, Isabella. *Giorgio de Chirico*. Milan: Fratelli Fabbri Editori, 1968.

Jeffrey, Ian. "Reflections on de Chirico." *London Magazine*, no. 3 (1985).

Gaffé, René. *Giorgio de Chirico, le Voyant*. Brussels: La Boétie, 1946.

George, Waldemar. *Chirico, avec des fragments littéraires de l'artiste*. Oaris: Chroniques du Jour, 1928.

Guzzi, Domenico. *Giorgio de Chirico, Arma virumque cano*. Rome: Leonardo Arte, 1988.

Guzzi, Virgilio. *Giorgio de Chirico*. Milan, 1976.

Helwig, Werner. *De Chirico - Peinture Métaphysique*. Paris: Éditions Hazan, 1962.

Lista, Giovanni. *De Chirico et l'Avant-Garde*. Lausanne: L'Age d'Homme, 1983.

Lo Duca, Giuseppe. *Giorgio de Chirico*. Milan: Edizioni Scheiwiller, 1936.

Melville, Robert. "Rousseau and de Chirico." *Scottish Arts and Letters*, no. 1 (1944).

Pica, Agnoldomenico. *12 opere di Giorgio de Chirico*. Milan: Ed. del Milione, 1944.

Quasimodo, Salvatore. *Giorgio de Chirico*. Rome: Alberto Marotta Editore, 1968.

Ragghianti, Carlo. "Il primo de Chirico." *La Critica d'Arte*, no. 1 (1949).

Sakraishik, Claudio Bruni. *Giorgio de Chirico*. Rome: Edizione La Medusa, 1976.

Sakraishik, Claudio Bruni. *I de Chirico di Sacerdoti*. Catalogue for the exhibition at the Galleria La Medusa, Rome, 1982.

Soby, James Thrall. *The Early Chirico*. New York: Dodd, Mead, 1941.

Vitrac, Roger. *Georges de Chirico et son œuvre*. Paris: Gallimard, 1927.

Waldberg, Patrick. *Giorgio de Chirico e la nascita della metafisica*. Milan: Fratelli Fabbri Editori, 1968.

Sélection. Cahier, no. 8 (1929) (special issue, Giorgio de Chirico).

Catalogues

1970. Exhibition catalogue, *Giorgio de Chirico*, Palazzo Reale, Milan; exhibition catalogue, *Giorgio de Chirico*, Hanover; exhibition catalogue, *I de Chirico di de Chirico*, Palazzo dei Diamanti, Ferrara.

1971. Publication begins of the *Catalogo Generale delle Opere di Giorgio de Chirico*, coordinated by Claudio Bruni Sakraishik, Edizione Electra, Milan.

1972. *De Chirico by De Chirico*. Catalogue for the exhibition held at the New York Cultural Center, New York, and in the Art Gallery, Ontario.

1973-1974. Catalogue for the itinerant exhibition in Japan.

1975. *De Chirico*. Catalogue for the Musée Marmottan, Paris.

1980. Exhibition catalogue for *La pittura metafisica*, Palazzo Grassi, Venice.

Pictor optimus pinxit. Giorgio de Chirico 1888-1978. Catalogue for the exhibition held at the Galleria Marescalchi, Bologna.

Giorgio de Chirico: Atelier intime. Catalogue for the exhibition held at the Château-Musée de Cagnes-sur-Mer.

1981. *Giorgio de Chirico*. Catalogue for the exhibition at the Musée des Beaux-Arts André Malraux, Le Havre.

Giorgio de Chirico. Catalogue for the exhibition at the Galleria Nazionale d'Arte Moderna, Rome.

Schmied, Wieland. *Giorgio de Chirico*. Catalogue for the exhibition at Artcurial, Paris.

1982. *Giorgio de Chirico*. Catalogues for the exhibitions in New York (Museum of Modern Art), London (The Tate Gallery) and Munich (Kunsthaus).

Giorgio de Chirico: Parigi 1924-1929. Volume published by Galleria Philippe Daverio, Milan (Maurizio Fagiolo dell'Arco - Paolo Baldacci).

De Chirico. Catalogue for the exhibition at the Seibu Museum of Art, Tokyo.

1983. *Giorgio de Chirico*. Catalogue for the exhibition held at the Centre Georges Pompidou, Paris.

1984. *Il ritorno del Cavaliere errante*. Catalogue for the exhibition held at the Palazzo Conti Passi di Villongo, Bergamo.

1985. *Late de Chirico*. Catalogue for the exhibition at the Arnolfini Gallery, Bristol.

De Chirico Neo-baroque. Catalogue for the exhibition at Artcurial, Paris.

1988. Catalogue for the retrospective exhibition held at the Museo Correr - Ala Napoleónica, Venice, on the occasion of the hundredth anniversary of the artist's birth.

ILLUSTRATIONS

1. *Battle between the Lapiths and the Centaurs*. 1909.
 Oil on canvas, 29½ × 44 in. (75 × 112 cm).
 Galleria Nazionale d'Arte Moderna, Rome.

2. *Dying Centaur*. 1909.
 Oil on canvas, 46 × 28¾ in. (117 × 73 cm).
 Assitalia Collection, Rome.

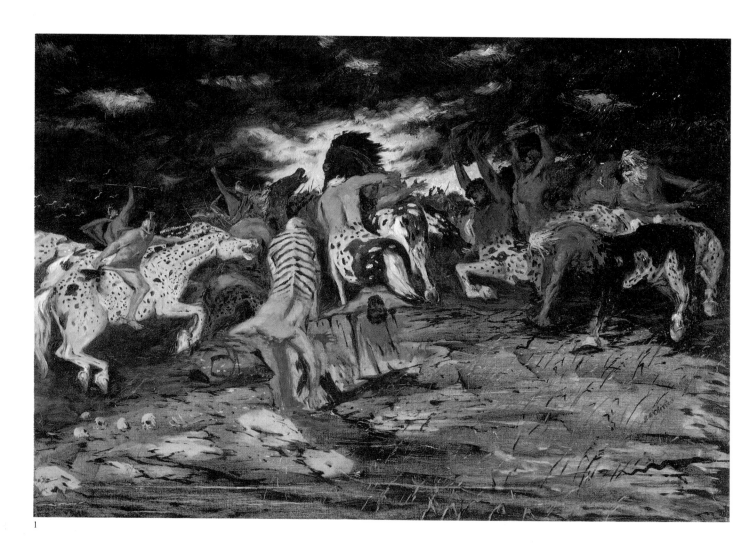

1

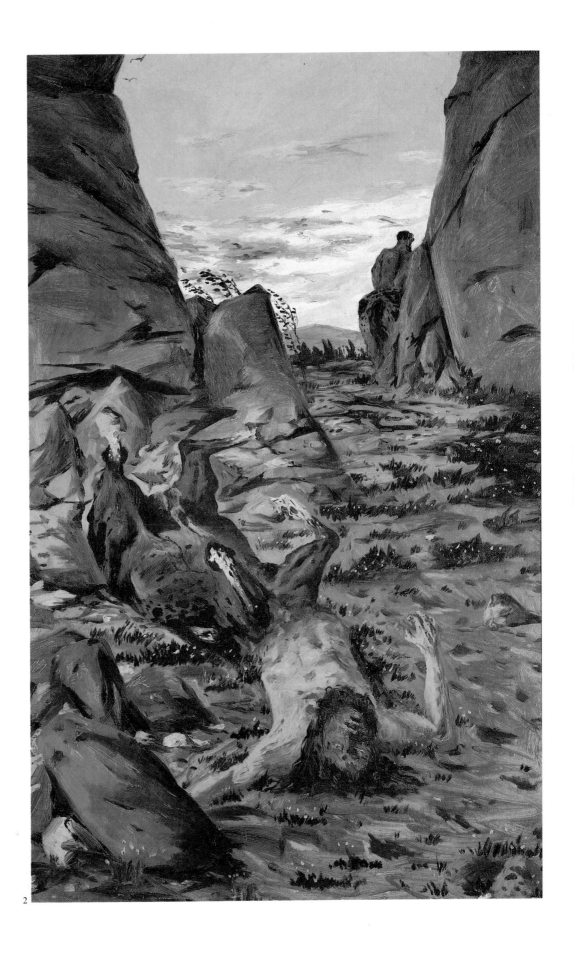

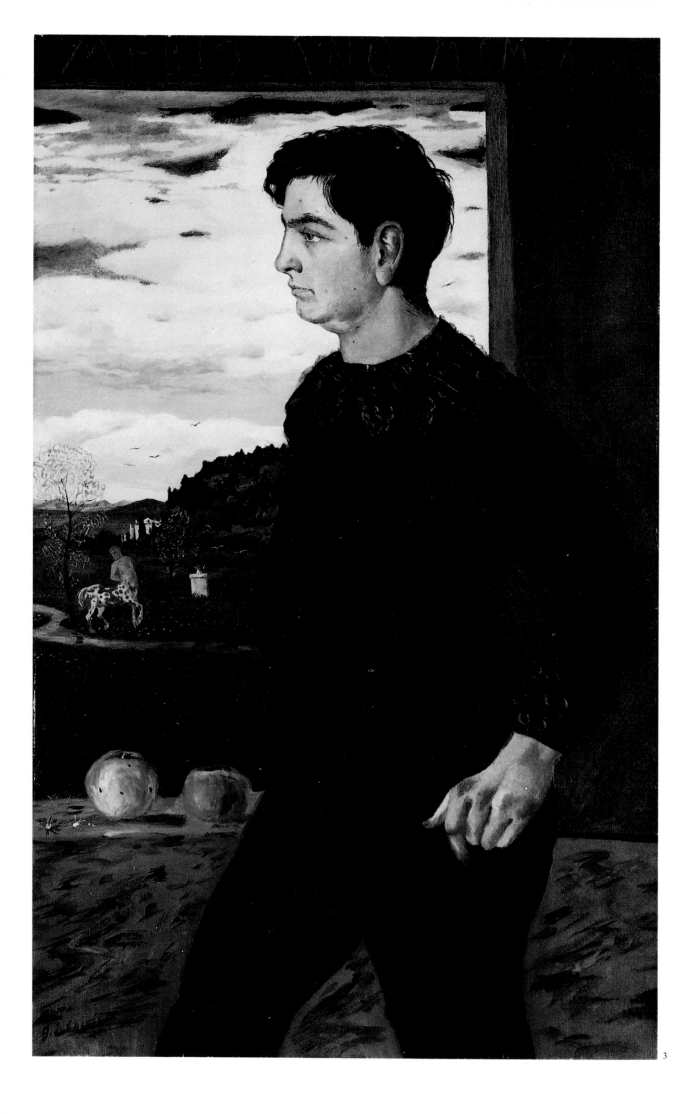

3. *Portrait of Andrea, the Artist's Brother*. 1910.
 Oil on canvas, 47 × 29½ in. (119 × 75 cm).
 Staatliche Museen, Nationalgalerie, Berlin.

4. *Portrait of the Artist's Mother*. 1911.
 Oil on canvas, 33¾ × 24½ in. (85.5 × 62 cm).
 Galleria Nazionale d'Arte Moderna, Rome.
 Isabella Pakszwer de Chirico Donation.

5. *Portrait of Mrs Gartzen*. 1913.
 Oil on canvas, 28¾ × 23½ in. (73 × 60 cm).
 Private Collection, Rome.

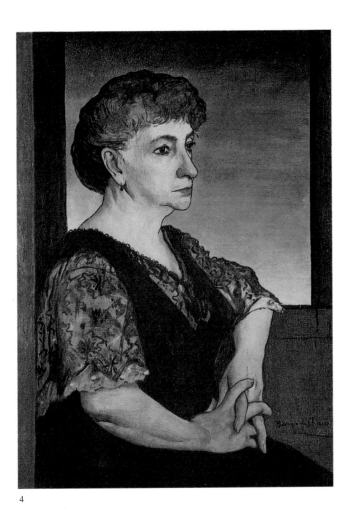

4

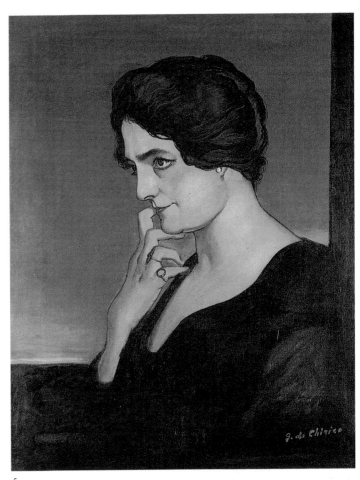

5

6. *The Enigma of the Arrival and the Afternoon*. 1912.
 Oil on canvas, 27½ × 34 in. (70 × 86 cm).
 Private Collection, New York.

7. *The Anxious Journey*. 1913.
 Oil on canvas, 29 × 42 in. (74 × 107 cm).
 The Museum of Modern Art, New York.

8. *The Soothsayer's Reward*. 1913.
 Oil on canvas, 53½ × 71¼ in. (136 × 181 cm).
 Philadelphia Art Museum,
 Louise and Walter Arensberg Collection, Philadelphia.

6

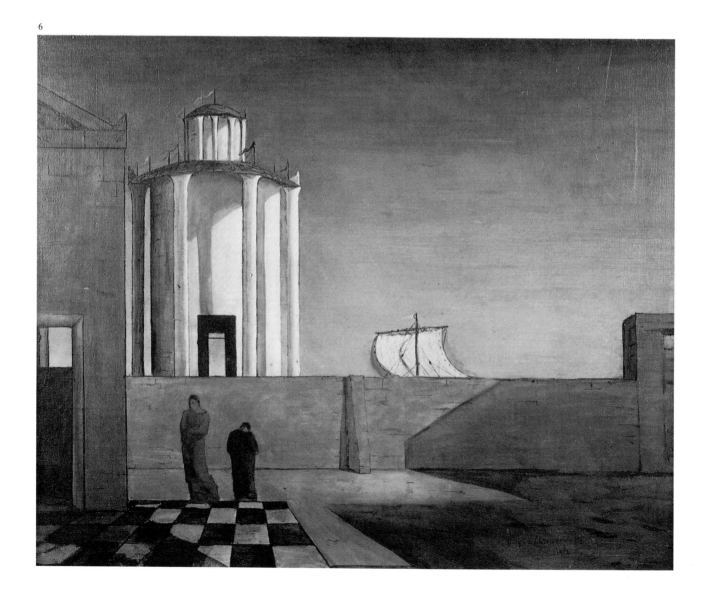

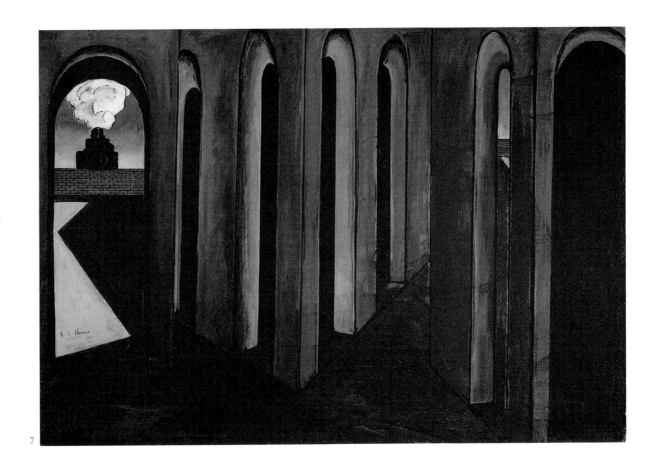

7

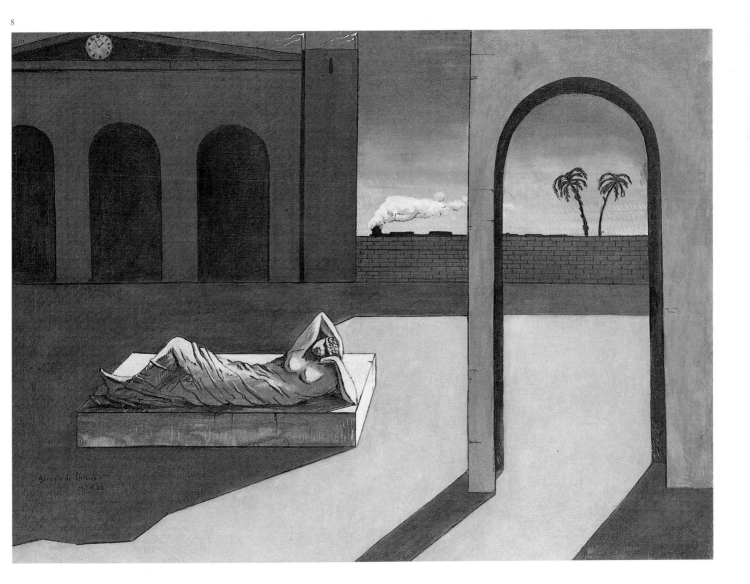

8

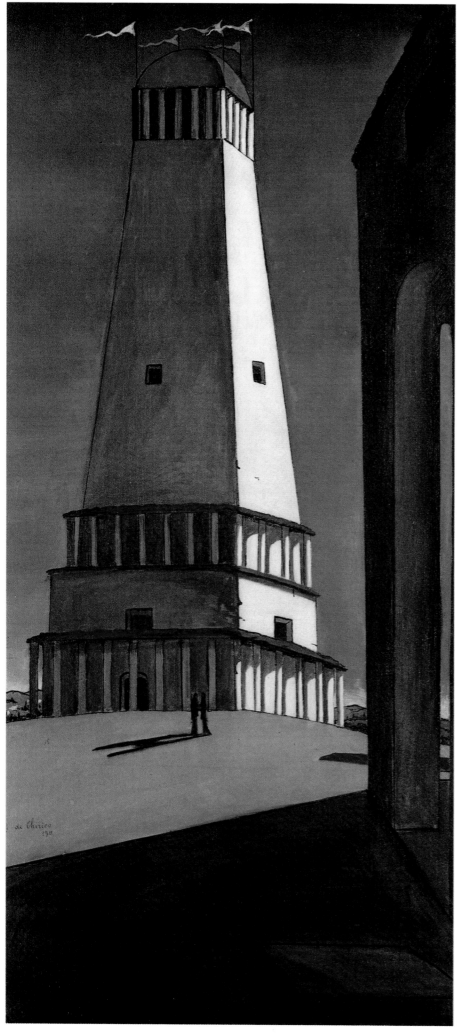

9. *The Nostalgia of the Infinite*. 1913.
 Oil on canvas, 53¼ × 25½ in. (135.5 × 64.8 cm).
 The Museum of Modern Art, New York.

10. *The Big Tower*. 1913.
 Oil on canvas, 48½ × 20¾ in. (123.5 × 52.5 cm).
 Kunstsammlung Nordrhein-Westfalen, Dusseldorf.

11. *The Tower*. 1913.
 Oil on canvas, 45½ × 17¾ in. (115 × 45 cm).
 Kunsthaus, Zurich.

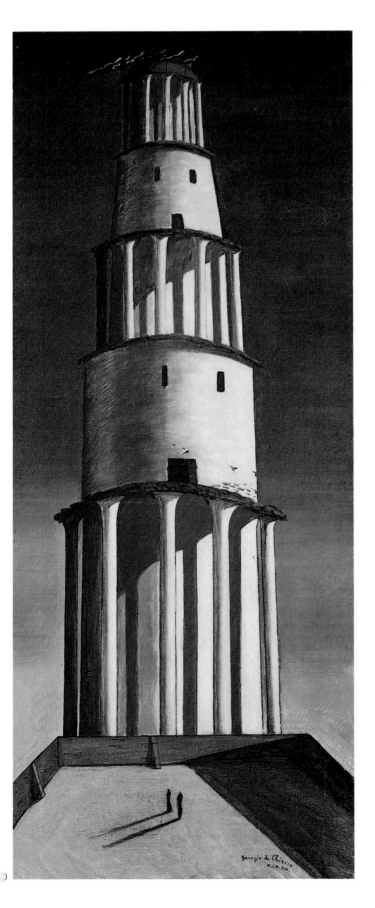

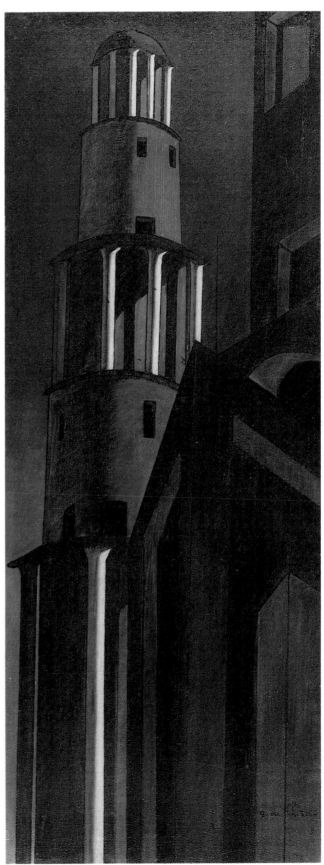

10

11

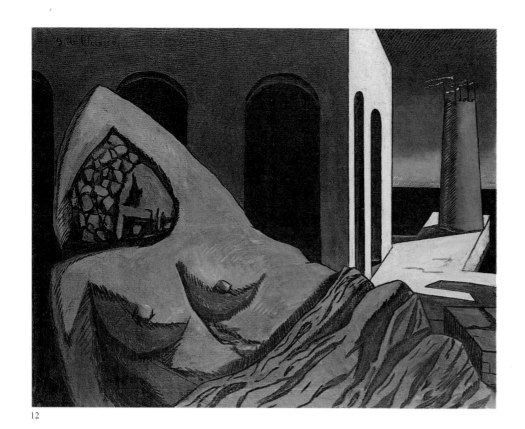

12

13

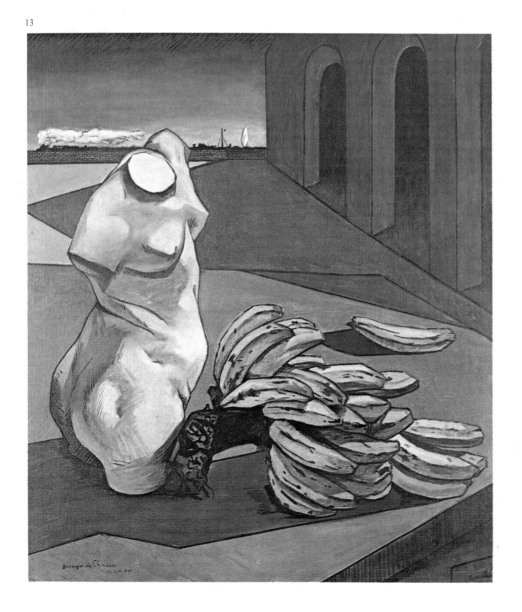

12. *The Silent Statue (Ariana)*. 1913.
 Oil on canvas, 39¼ × 49½ in. (99.5 × 125.5 cm).
 Kunstsammlung Nordrhein-Westfalen, Dusseldorf.

13. *The Poet's Uncertainty*. 1913.
 Oil on canvas, 50 × 36¼ in. (104 × 92 cm).
 Tate Gallery, London.

14. *Montparnasse Station*. 1914.
 Oil on canvas, 55 × 72½ in. (140 × 184.5 cm).
 The Museum of Modern Art, New York.
 James T. Soby Legacy.

14

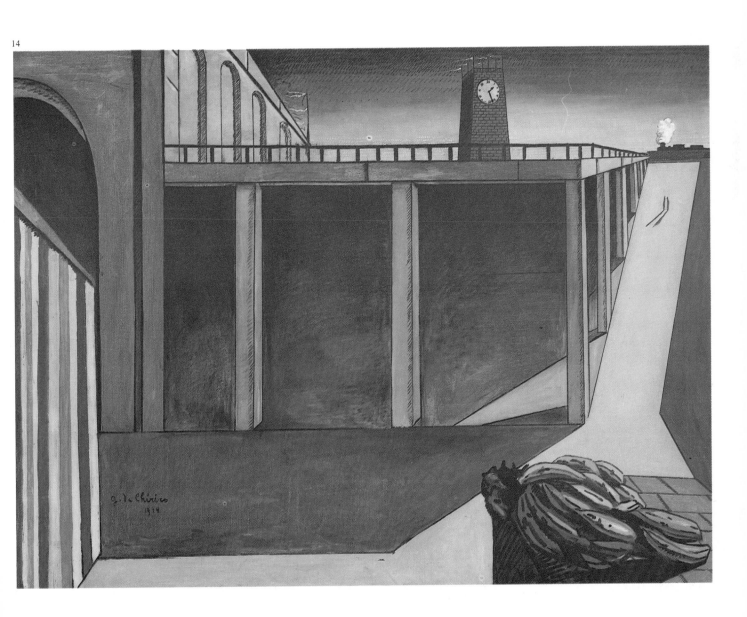

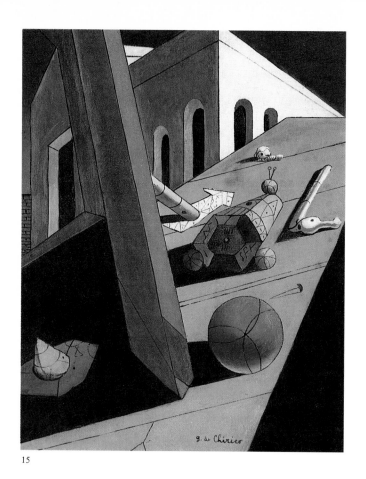

15

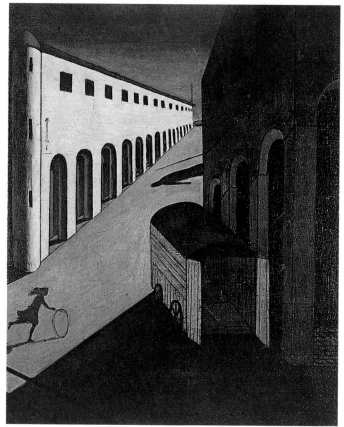

16

17

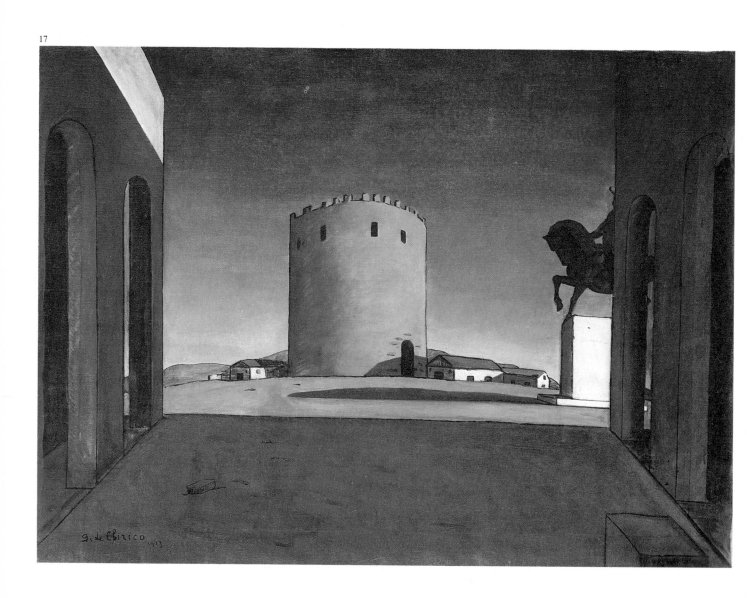

15. *A King's Bad Mood*. 1914-1915.
 Oil on canvas, 24 × 20 in. (61 × 50.5 cm).
 The Museum of Modern Art, New York.

16. *Mystery and Melancholy of a Street*. 1914.
 Oil on canvas, 34¼ × 28 in. (87 × 71.5 cm).
 Private Collection.

17. *The Red Tower*. 1913.
 Oil on canvas, 29 × 39½ in. (73.5 × 100.5 cm).
 Peggy Guggenheim Foundation, Venice.

18. *The Enigma of Fatality*. 1914.
 Oil on canvas, 54¼ × 37½ in. (138 × 95.5 cm).
 Kunstmuseum, Basel,
 Emmanuel Hoffmann Foundation trust.

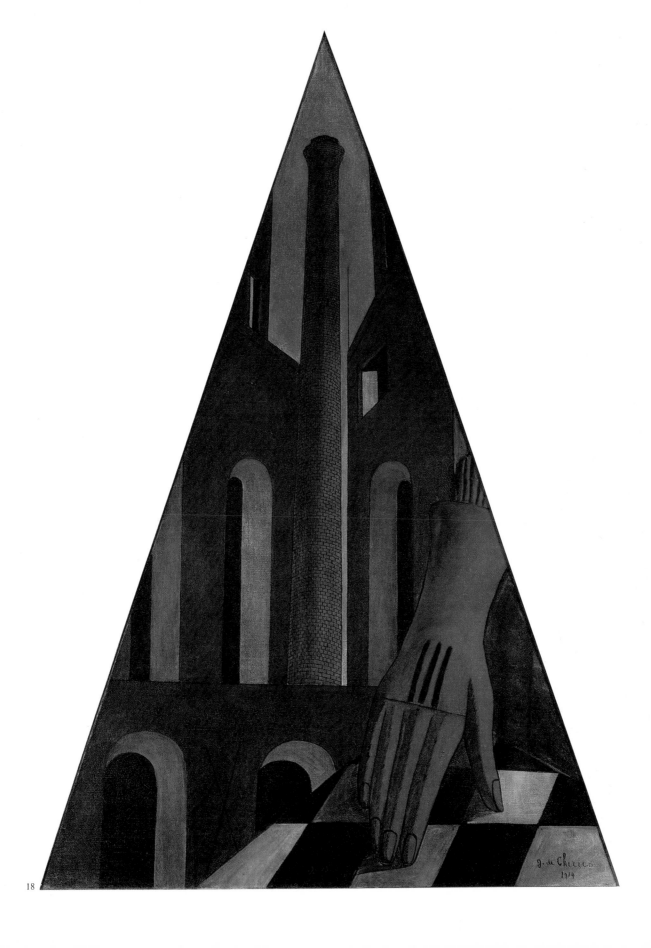

18

19. *The Poet's Dream*. 1914.
 Oil on canvas, 35¼×16 in. (89.5×40.5 cm).
 Peggy Guggenheim Foundation, Venice.

20. *Portrait of Guillaume Apollinaire*. 1914.
 Oil on canvas, 32×25½ in. (81.5×65 cm).
 Centre Georges Pompidou, Paris.

21. *Le Cerveau de l'Enfant* (The Child's Brain). 1914.
 Oil on canvas, 31½×24¾ in. (80×63 cm).
 Moderna Museet, Stockholm.

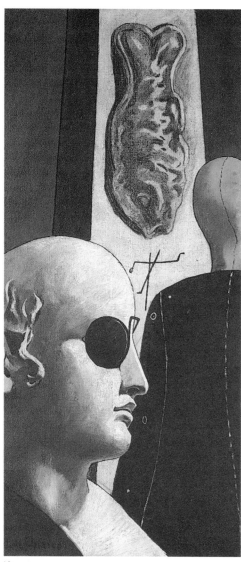

19

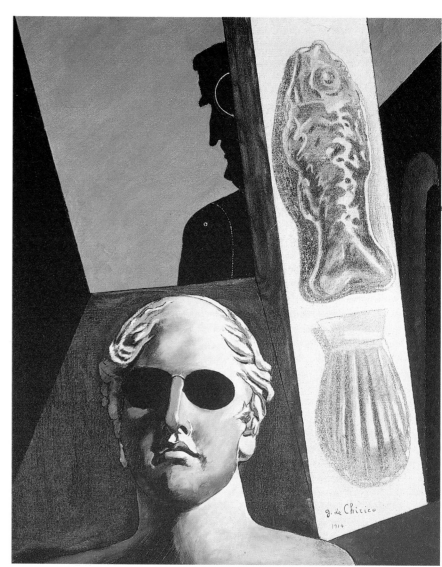

20

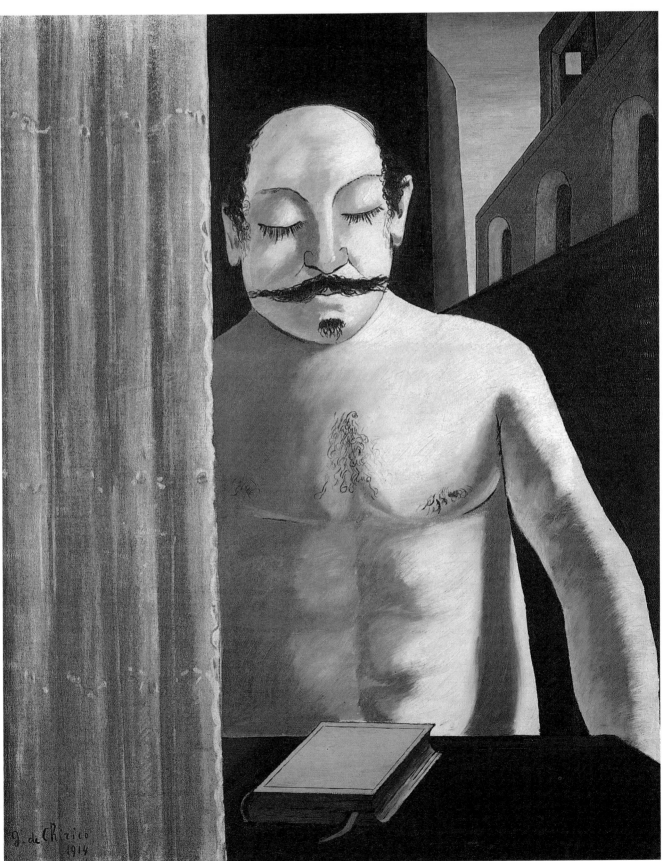

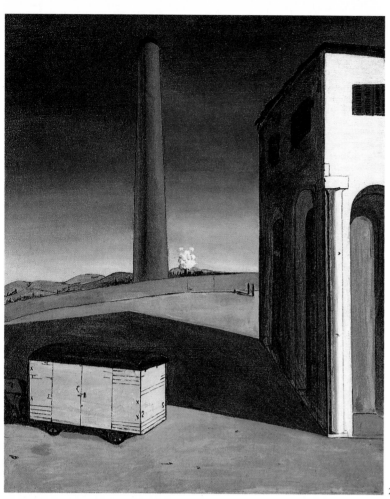

22

22. *The Anguish of Departing.* 1913-1914.
Oil on canvas, 33¼ × 27 in. (85 × 69 cm).
Albright-Knox Art Gallery, Buffalo.

23. *The Philosopher's Conquest.* 1914.
Oil on canvas, 49¼ × 39 in. (125 × 99 cm).
Art Institute, Chicago.
Joseph Winterbotham Collection.

24. *Love Song.* 1914.
Oil on canvas, 28¾ × 23¼ in. (73 × 59.1 cm).
The Museum of Modern Art, New York.
Rockefeller Legacy.

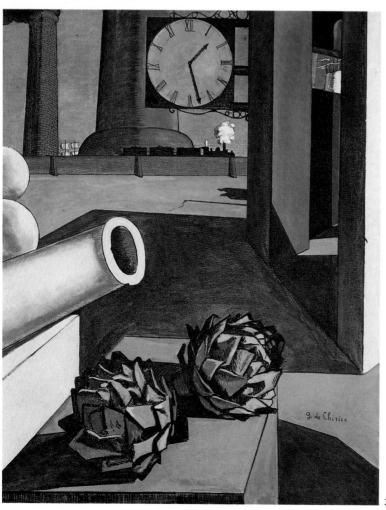

23

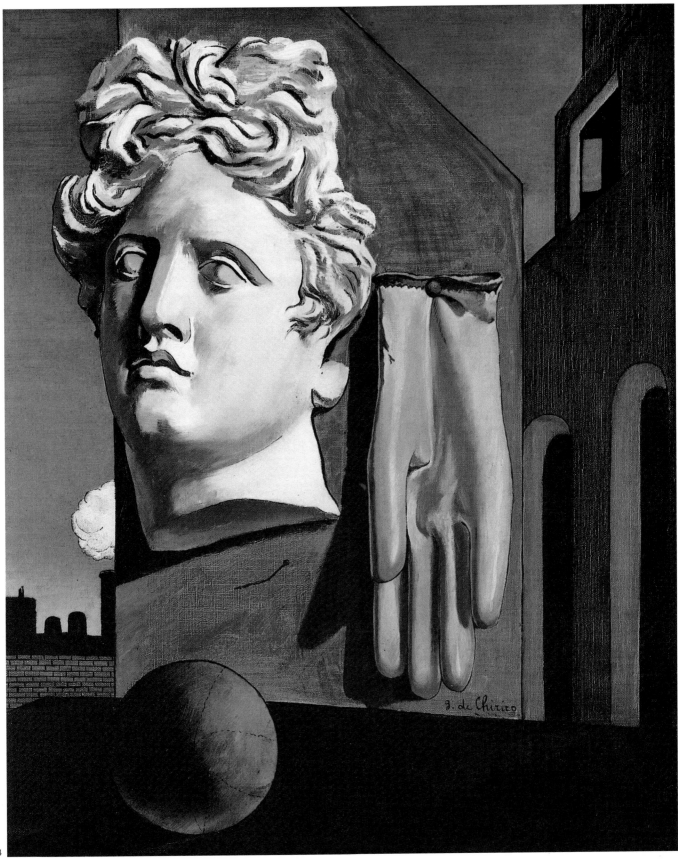

25. *The Philosopher and the Poet*. 1914.
Oil on canvas, 32¾×26 in. (83×66 cm).
Modern Gallery, Geneva.

26. *The Prophet*. 1915.
Oil on canvas, 35¼×27½ in. (89.6×70 cm).
The Museum of Modern Art, New York.
James T. Soby Legacy.

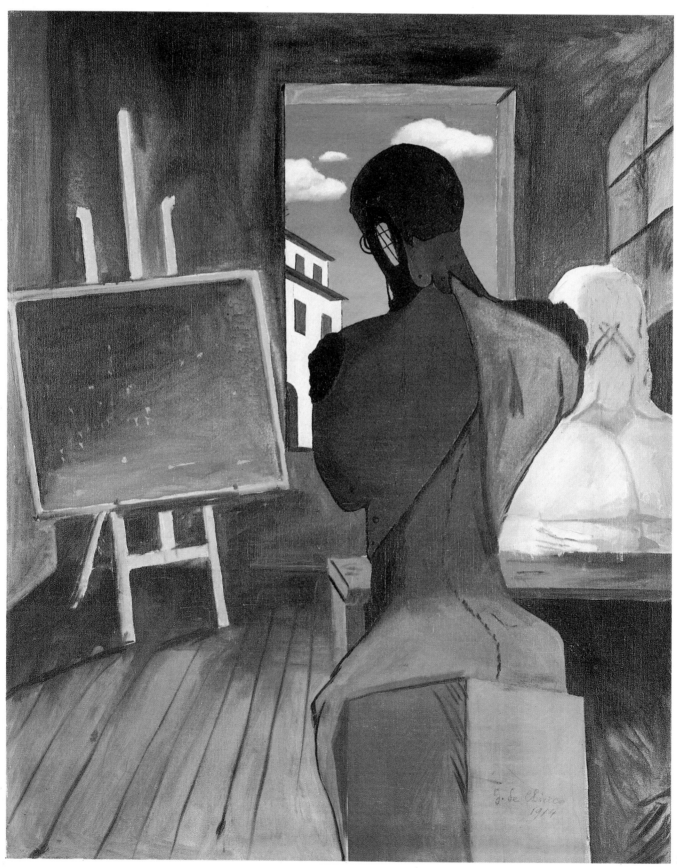

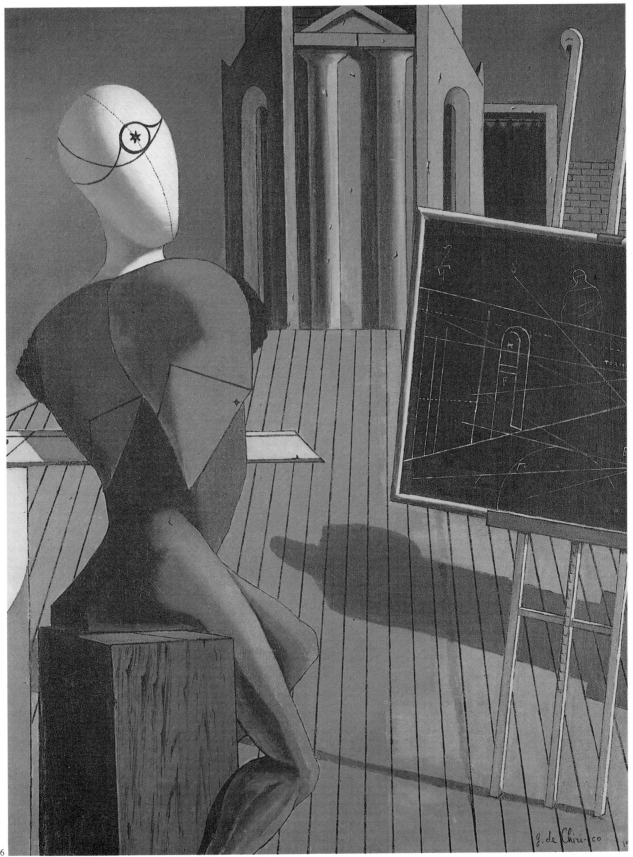

27

27. *The Double Dream of Spring*. 1915.
Oil on canvas, 22 × 21½ in. (56.2 × 54.3 cm).
The Museum of Modern Art, New York.
James T. Soby Legacy.

28. *The Duo*. 1915.
Oil on canvas, 32¼ × 23¼ in. (82 × 59 cm).
The Museum of Modern Art, New York.
James T. Soby Legacy.

29. *The Two Sisters*. 1915.
Oil on canvas, 21½ × 18 in. (55 × 46 cm).
Kunstsammlung Nordrhein-Westfalen, Dusseldorf.

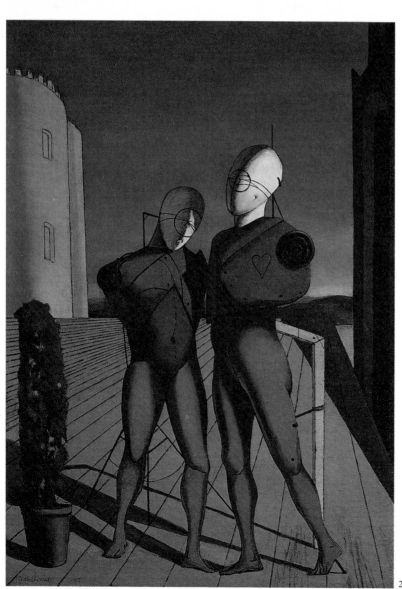

28

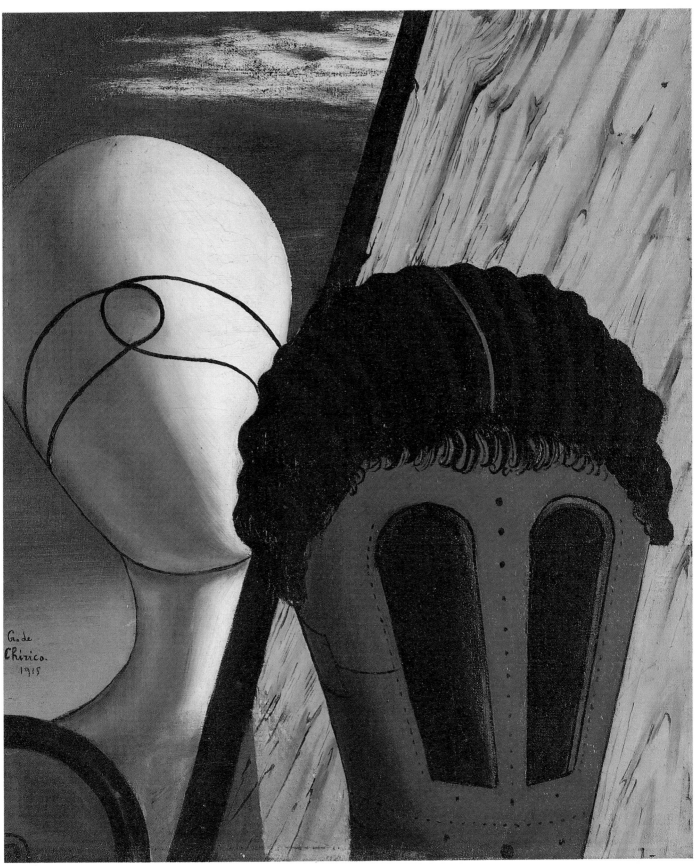

30. *The Prince's Toys*. 1915.
Oil on canvas, 21¾ × 10¼ in. (55.5 × 26 cm).
The Museum of Modern Art, New York.
Pierre Matisse Donation.

31. *The Joy of the Return*. 1915.
Oil on canvas, 33½ × 27 in. (85 × 68.5 cm).
Mr. and Mrs. James W. Alsdorf
Collection, Chicago.

32. *The Melancholy of Departure*. 1916.
Oil on canvas, 20 × 14½ in. (50.5 × 34 cm).
Tate Gallery, London.

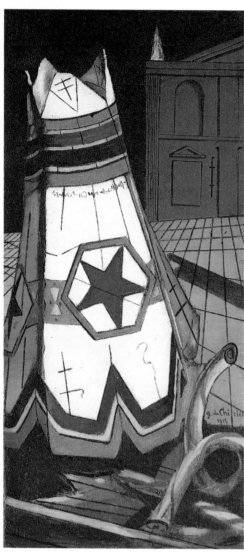

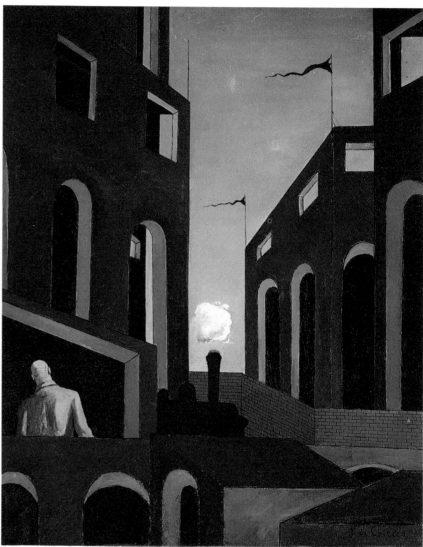

30

31

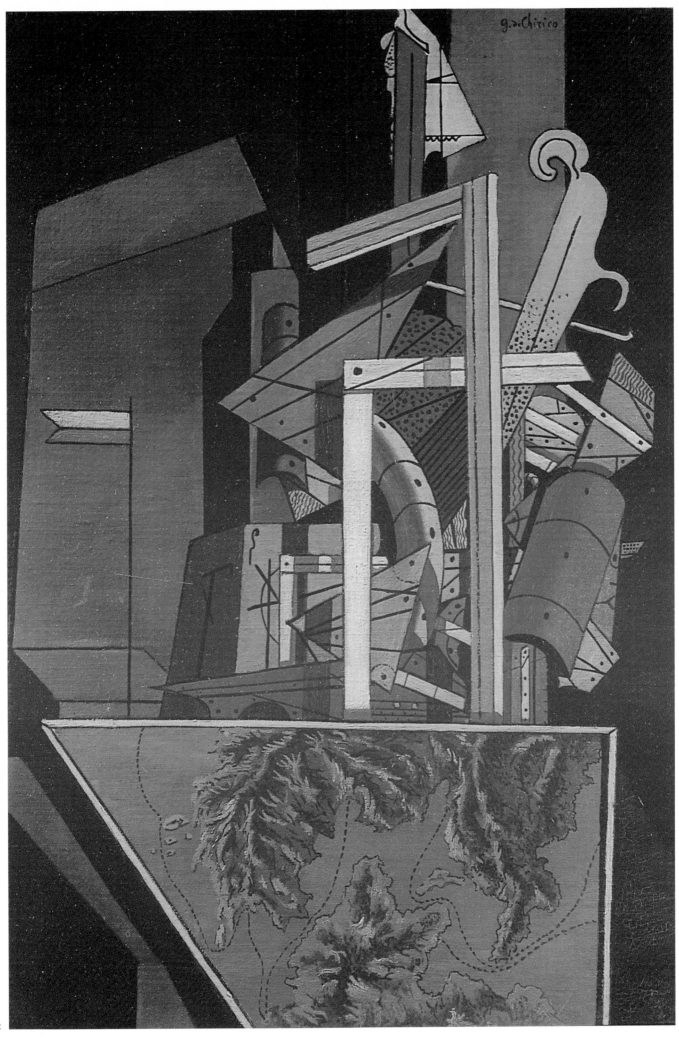

32

33. *The Delicate Afternoon*. 1916.
 Oil on canvas, 25½ × 22¾ in. (65 × 58 cm).
 Peggy Guggenheim Foundation, Venice.

34. *Greetings from a Distant Friend*. 1916.
 Oil on canvas, 19 × 14½ in. (48.2 × 36.5 cm).
 Private Collection, Rome.

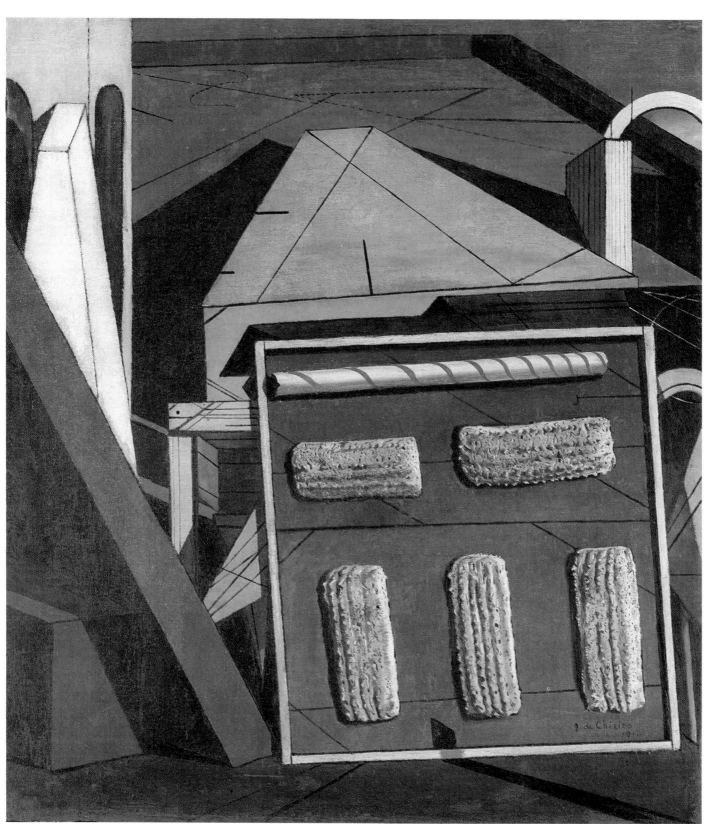

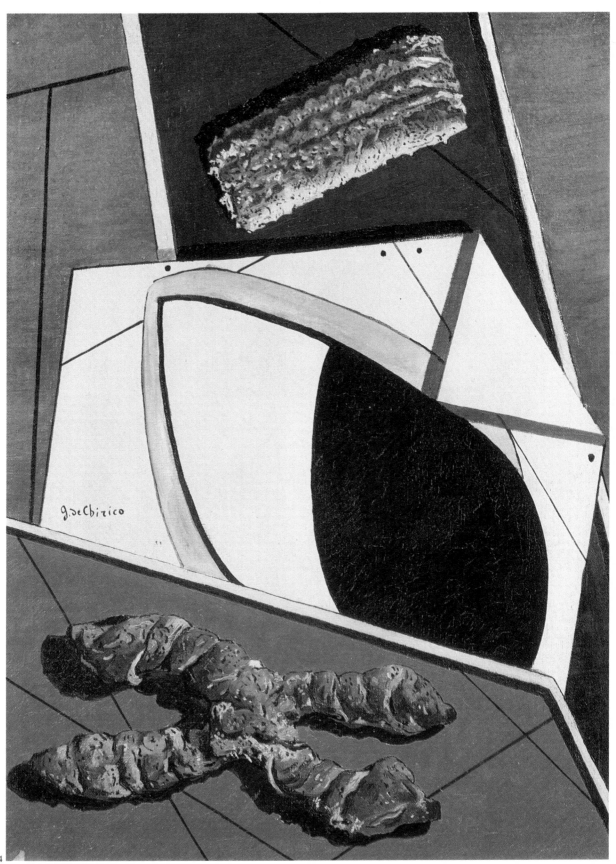

35. *The Great Metaphysician*. 1917.
Oil on canvas, 41 × 27½ in. (104.5 × 69.8 cm).
The Museum of Modern Art, New York.
Philip L. Goodwin Collection.

36. *The Sacred Fish*. 1918.
Oil on canvas, 29½ × 24½ in. (75 × 62 cm).
The Museum of Modern Art, New York.

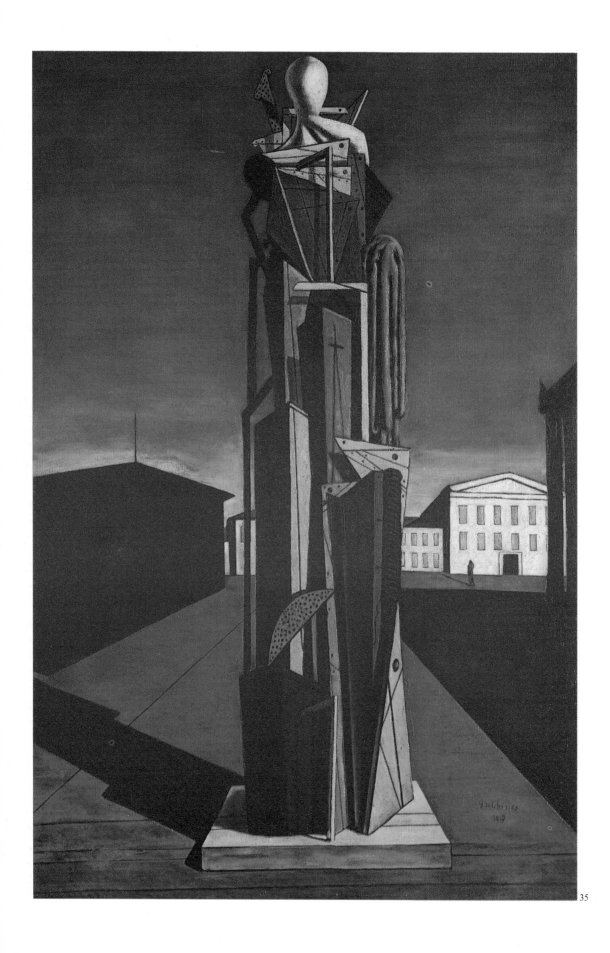

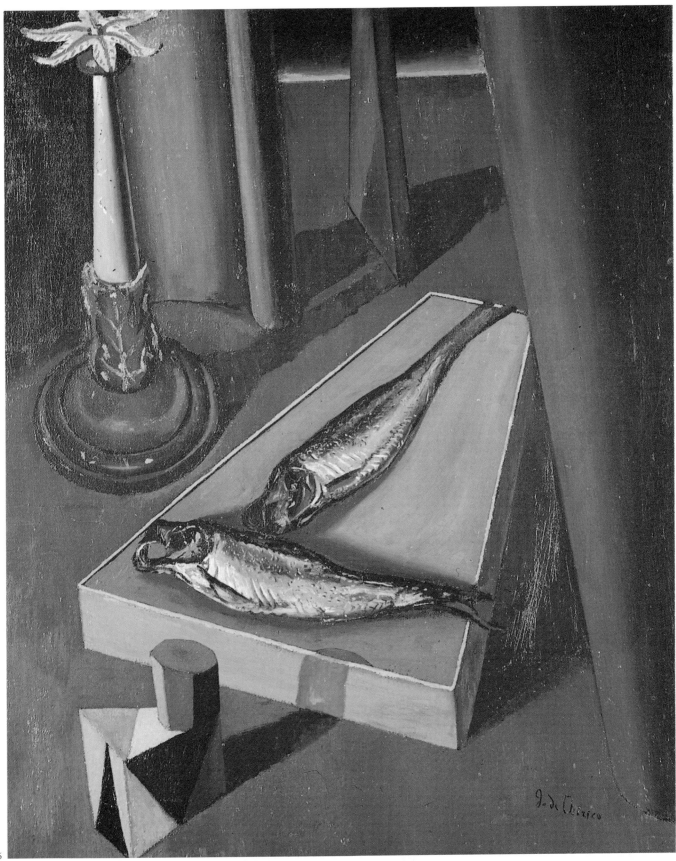

37. *The Pregnant Woman (after Raphael)*. 1920.
 Oil on canvas, 25½ × 19¼ in. (65 × 49 cm).
 Galleria Nazionale d'Arte Moderna, Rome.
 Isabella Pakszwer de Chirico Donation.

38. *Saint George*. 1920.
 Oil on canvas, 13¾ × 9½ in. (35 × 24 cm).
 Casella Collection.

39. *Lucretia*. 1922.
 Oil on canvas, 68½ × 30 in. (174 × 76 cm).
 Galleria Nazionale d'Arte Moderna, Rome.
 Isabella Pakszwer de Chirico Donation.

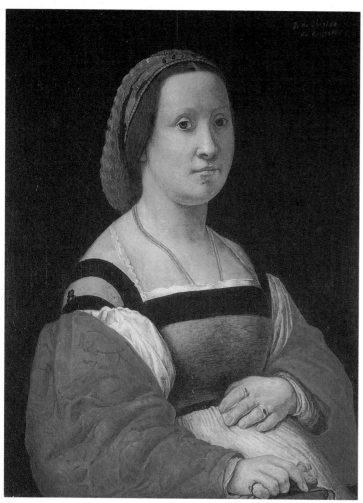

37

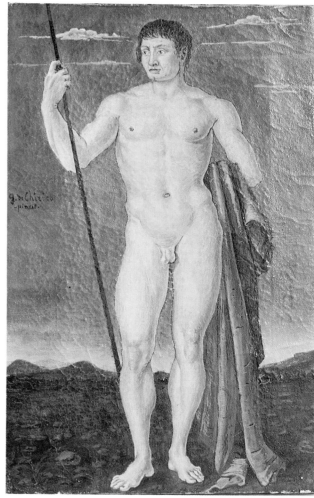

38

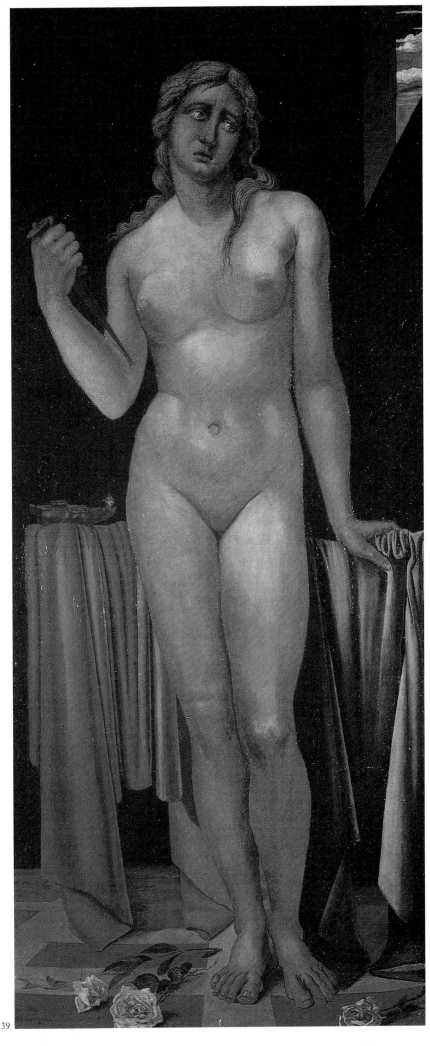

39

40. *The Poet's Farewells (Tibulus and Mesala)*. 1923.
Tempera on canvas, 25 × 19½ in. (64 × 49.5 cm).
Mario Cambi Collection, Rome.

41. *The House within the House*. 1924.
Oil on canvas, 28¾ × 21 in. (73 × 53 cm).
Mario Cambi Collection, Rome.

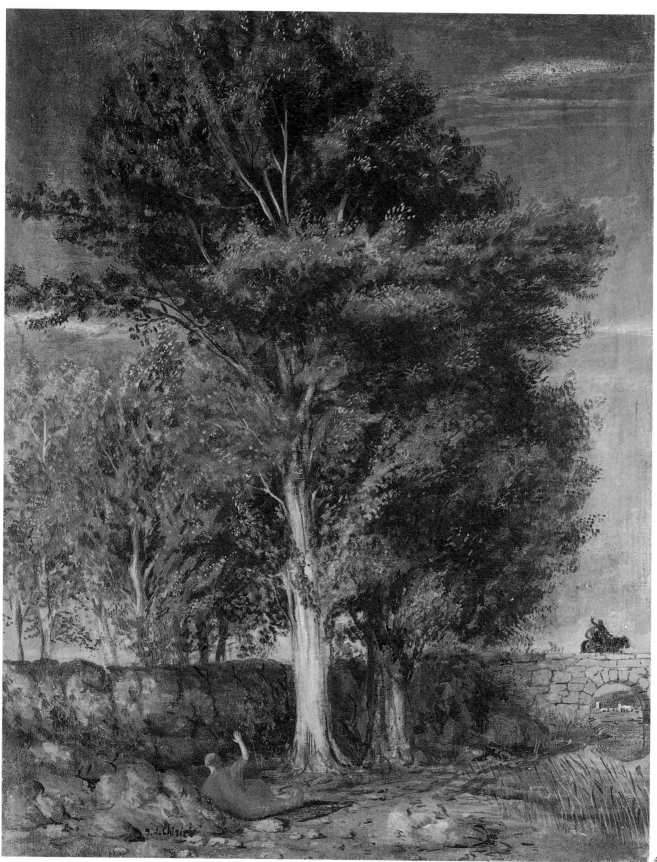

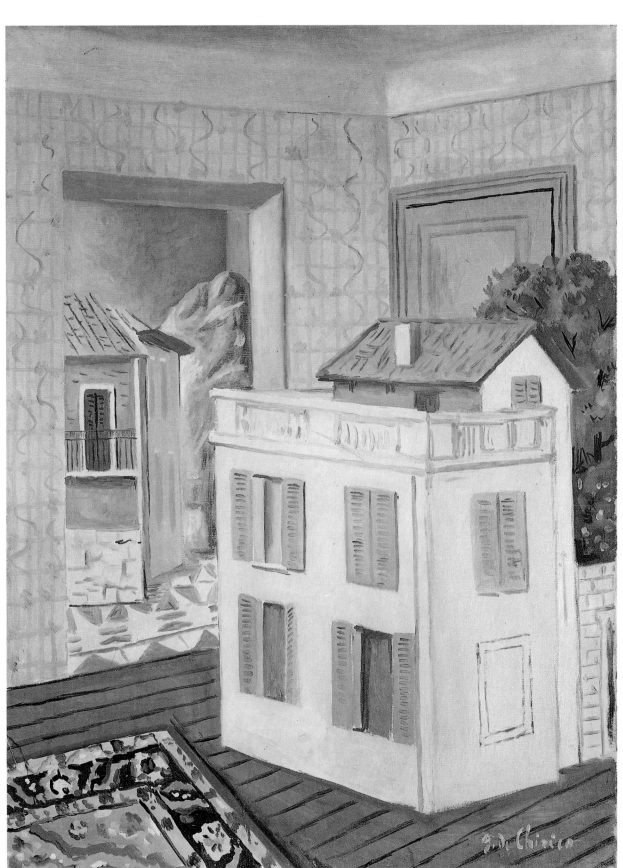

41

42. *Hector and Andromache. c.* 1924.
Oil on canvas, 38¾×29¼ in. (98.5×74.5 cm).
Galleria Nazionale d'Arte Moderna, Rome.

43. *The Great Automaton.* 1925.
Oil on canvas, 43¼×25½ in. (110×65 cm).
Museum of Honolulu.

44. *The Disturbing Muses.* 1925.
Oil on canvas, 38¼×26½ in. (97×67 cm).
Galleria Nazionale d'Arte Moderna, Rome.
Isabella Pakszwer de Chirico Donation.

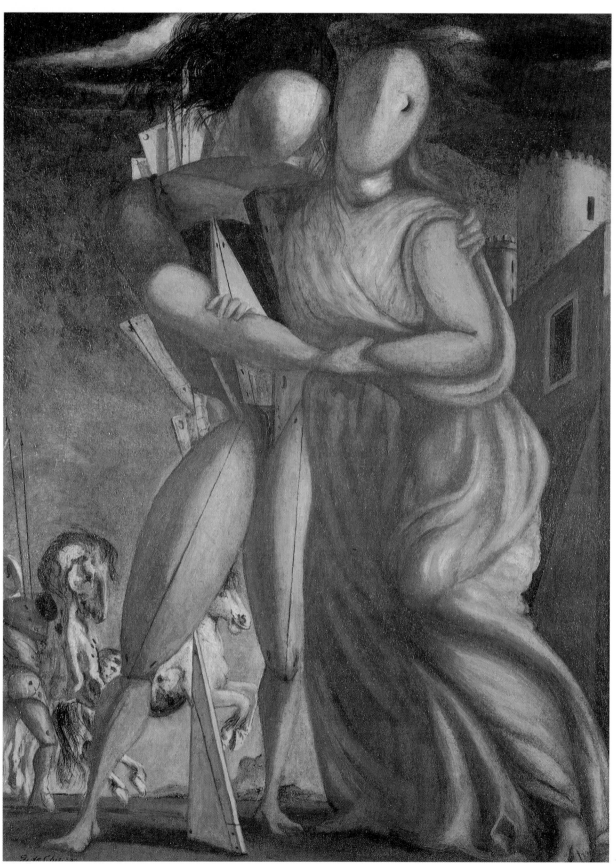

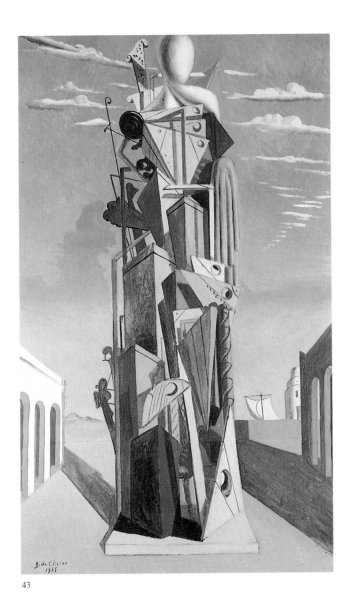

43

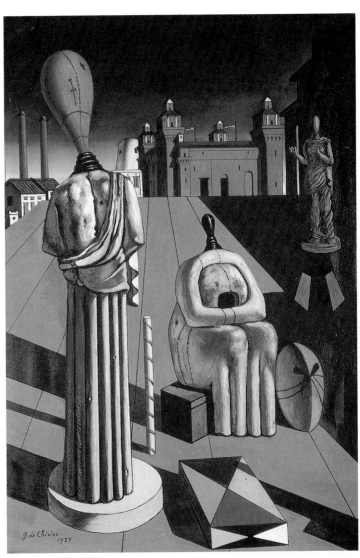

44

45. *Self-Portrait*. 1920.
 Oil on canvas, 19¾ × 15½ in. (50 × 39.5 cm).
 Staatsgalerie Moderner Kunst, Munich.

46. *Self-Portrait*. 1925.
 Oil on cardboard, 24½ × 18 in. (62.5 × 46 cm).
 Galleria Nazionale d'Arte Moderna, Rome.

47. *The Peasant Woman*. 1925.
 Oil on canvas, 33 × 26¾ in. (84 × 68 cm).
 Private Collection, Rome.

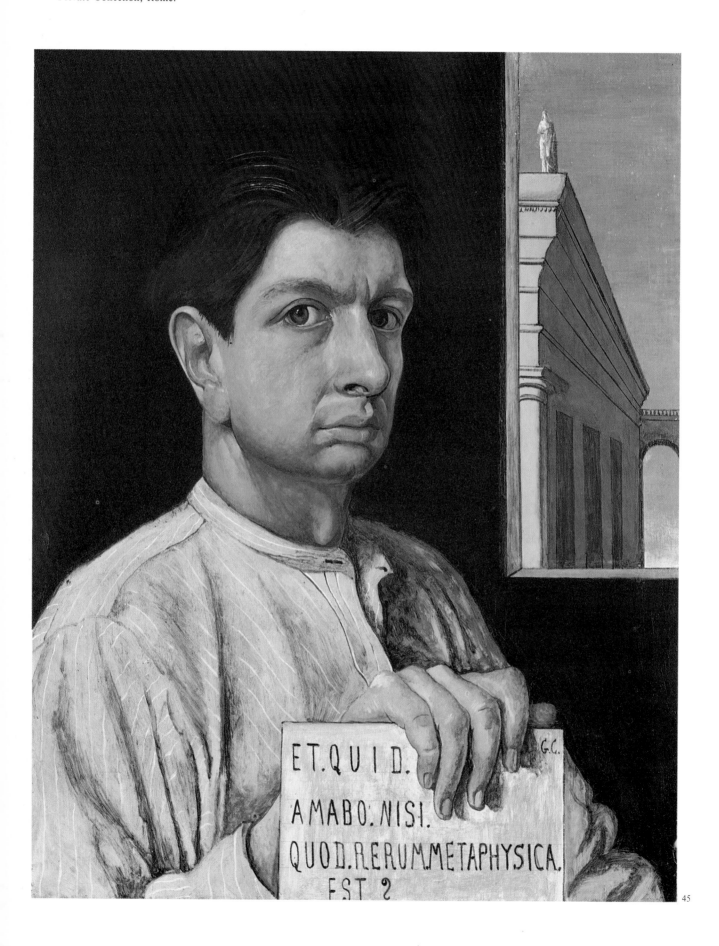

45

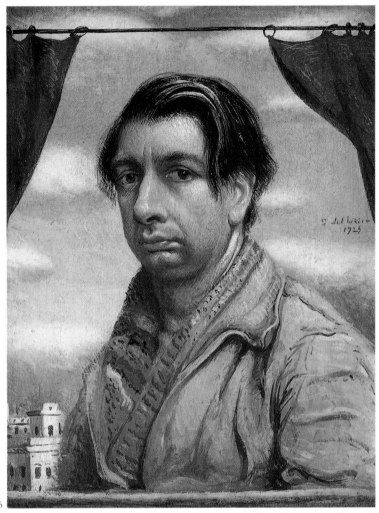

46

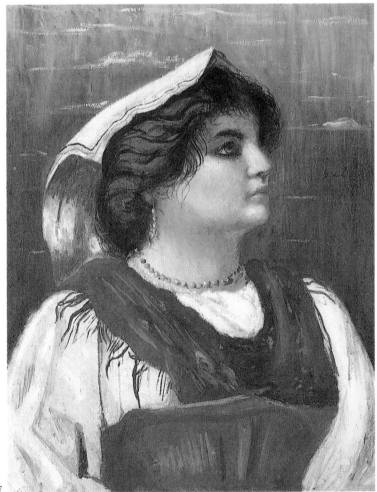

47

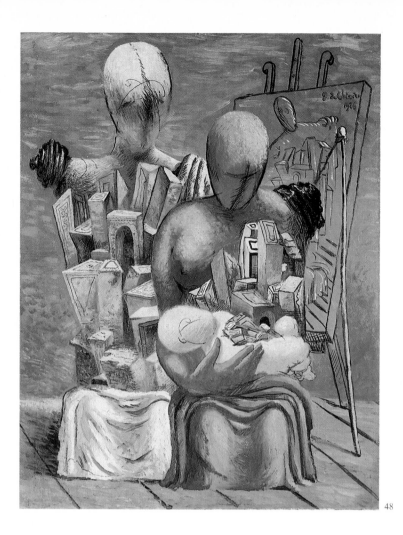

48

48. *The Painter's Family*. 1926.
Oil on canvas, 57¾ × 45¼ in. (146.5 × 115 cm).
Tate Gallery, London.

49. *Interview*. 1927.
Oil on canvas, 51¼ × 38¼ in. (130 × 97 cm).
National Gallery, Washington.
Chester Dale Collection.

50. *The Archaeologists*. 1927.
Oil on canvas, 45¾ × 35 in. (116 × 89 cm).
Galleria Nazionale d'Arte Moderna, Rome.
Isabella Pakszwer de Chirico Donation.

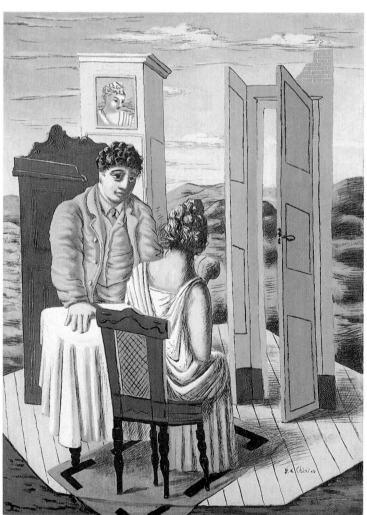

49

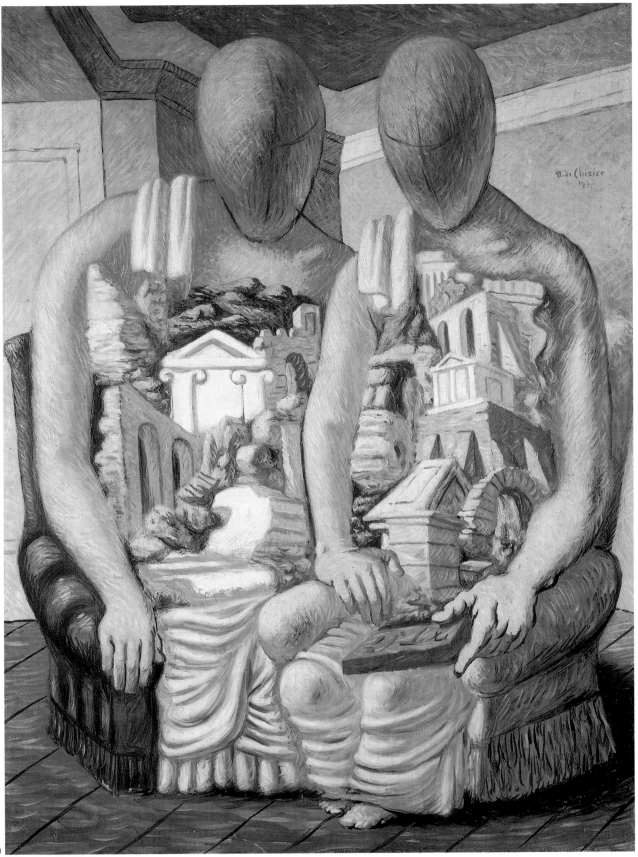

51. *The Shores of Thessaly*. 1926.
 Oil on canvas, 36¼ × 28¾ in. (92 × 73 cm).
 Private Collection.

52. *Furniture in the Valley*. 1927.
 Oil on canvas, 51¼ × 38¼ in. (130 × 97 cm).
 Private Collection, Rome.

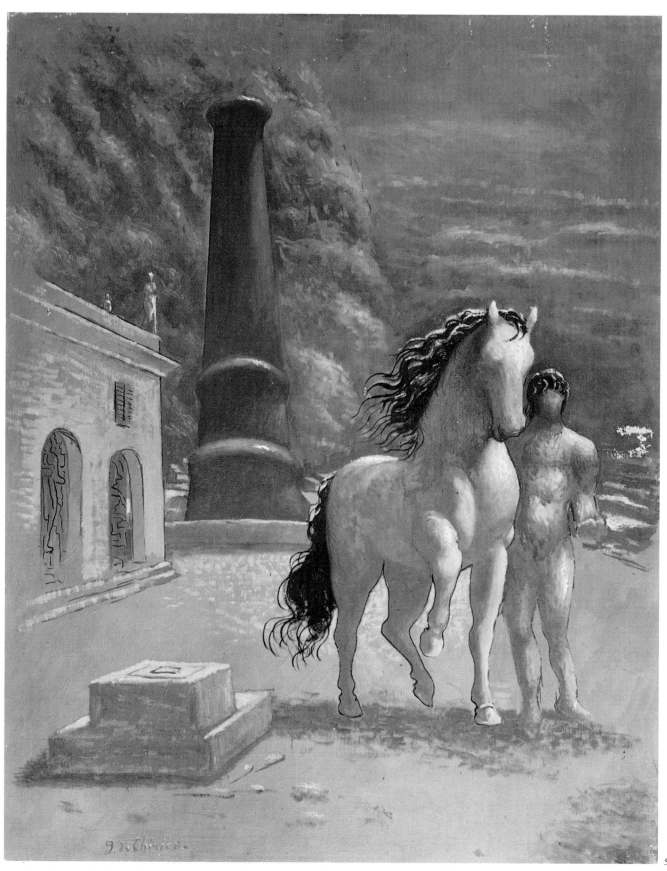

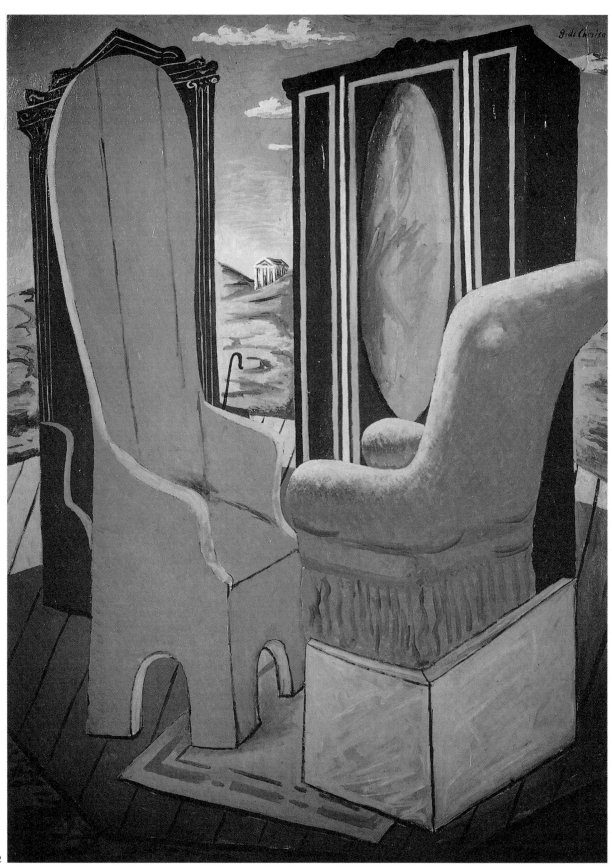

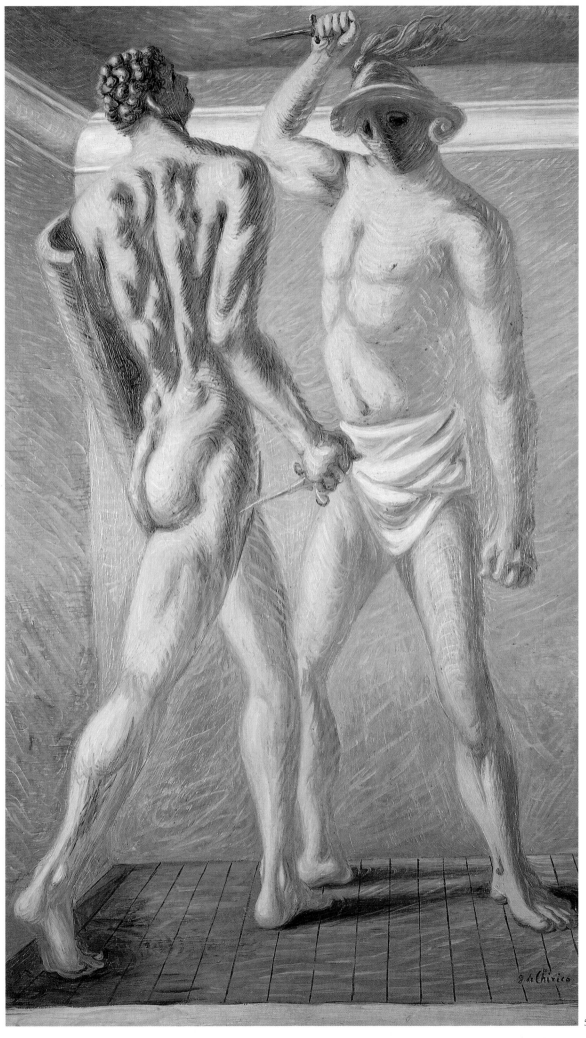

53. *Gladiators*. 1928.
 Oil on canvas, 63 × 37½ in. (160 × 95 cm).
 Private Collection, Rome.

54. *Still Life*. 1929.
 Oil on canvas, 28¾ × 39¾ in. (73 × 101 cm).
 Galleria Nazionale d'Arte Moderna, Rome.

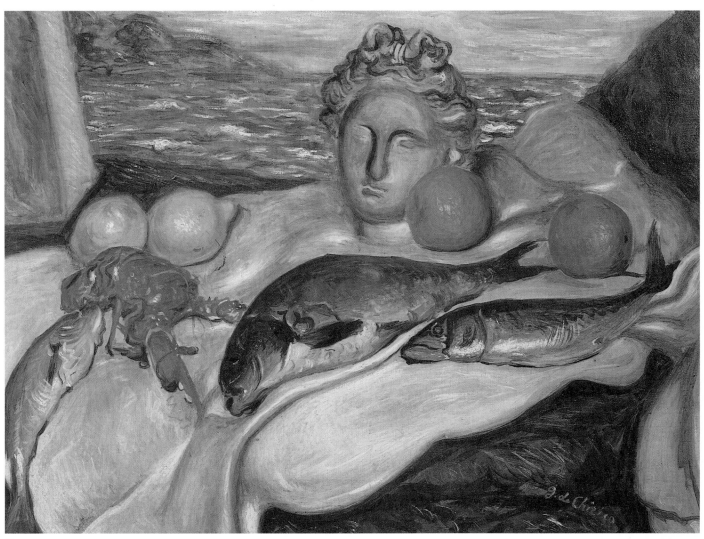

54

55. *Little Oriental Head*. 1929.
Oil on canvas, 15¾ × 11¾ in. (40 × 30 cm).
Private Collection, Trieste.

56. *Nude Woman*. 1929.
Oil on canvas, 35¾ × 29 in. (91 × 74 cm).
Antonio Russo Collection, Rome.

57. *Naked Woman on the Beach* (The
Repose of Alcmena). 1932.
Oil on canvas, 28 × 53¼ in. (71.5 × 135.5 cm).
Galleria Nazionale d'Arte Moderna, Rome.
Isabella Pakszwer de Chirico Donation.

58. *Diana Sleeping in the Wood*. 1933.
Oil on canvas, 35½ × 46 in. (90.5 × 117 cm).
Galleria Nazionale d'Arte Moderna, Rome.
Isabella Pakszwer de Chirico Donation.

55

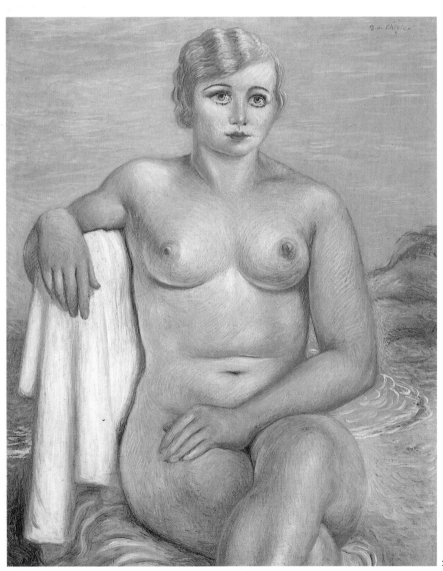

56

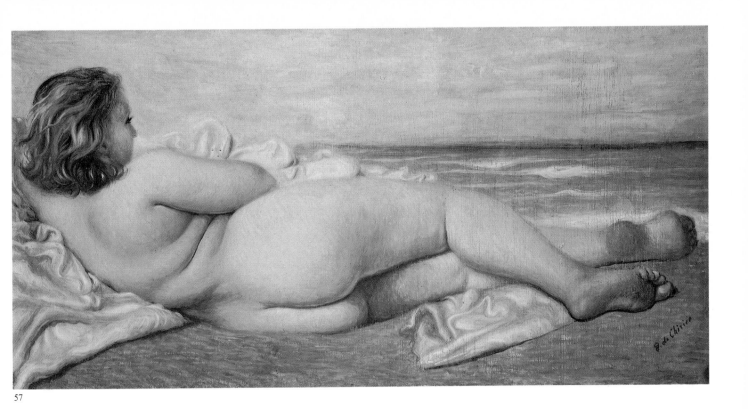

57

58

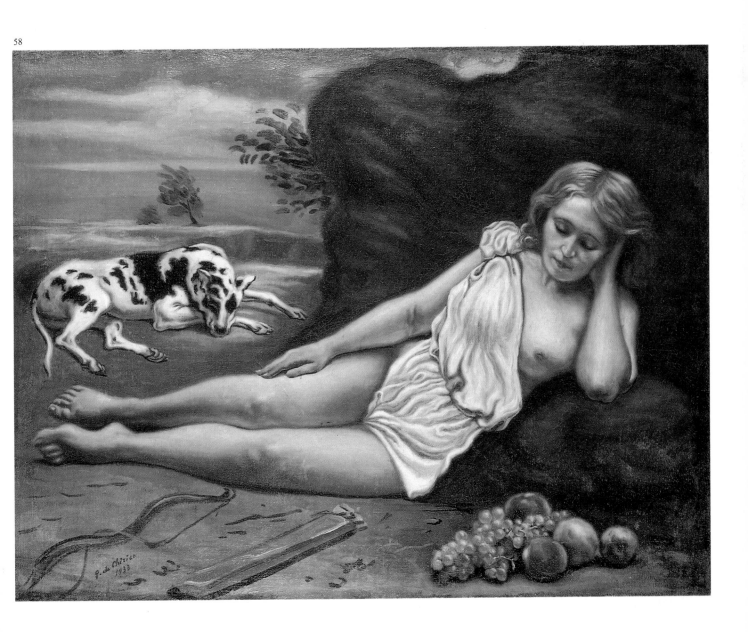

59

59. *Portrait of Isa*. 1933.
 Oil on canvas, 17¼ × 14½ in. (44 × 37 cm).
 Private Collection, Rome.

60. *Bathers on the Beach*. 1934.
 Oil on canvas, 43¼ × 59 in. (110 × 150 cm).
 Private Collection, Rome.

61. *Amazon*. 1934.
 Oil on canvased cardboard, 23½ × 19¾ in. (60 × 50 cm).
 Private Collection, Rome.

60

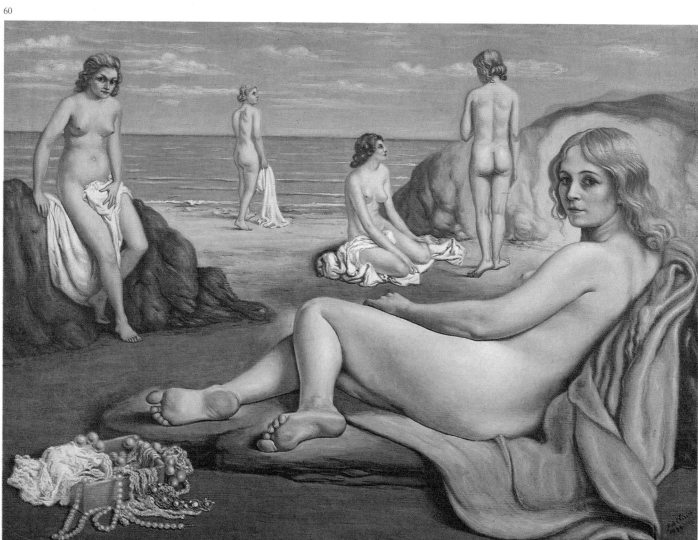

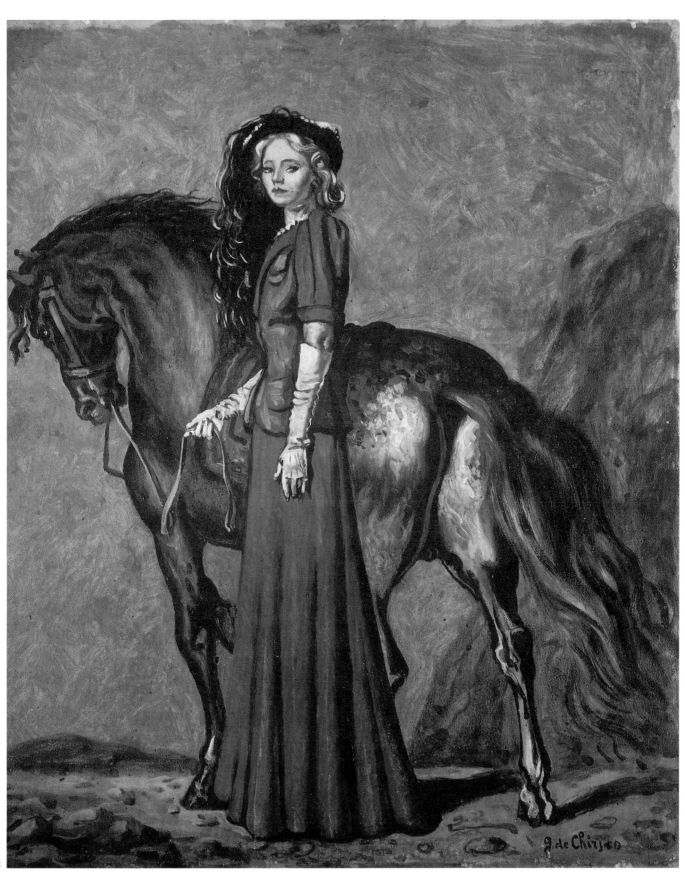

62. *Gladiators*. 1932.
 Oil on canvas, 23½ × 19¾ in. (60 × 50 cm).
 Galleria Nazionale d'Arte Moderna, Rome.
 Isabella Pakszwer de Chirico Donation.

63. *Changing Huts*. 1935.
 Oil on canvas, 19¾ × 15¾ in. (50 × 40 cm).
 Private Collection, Rome.

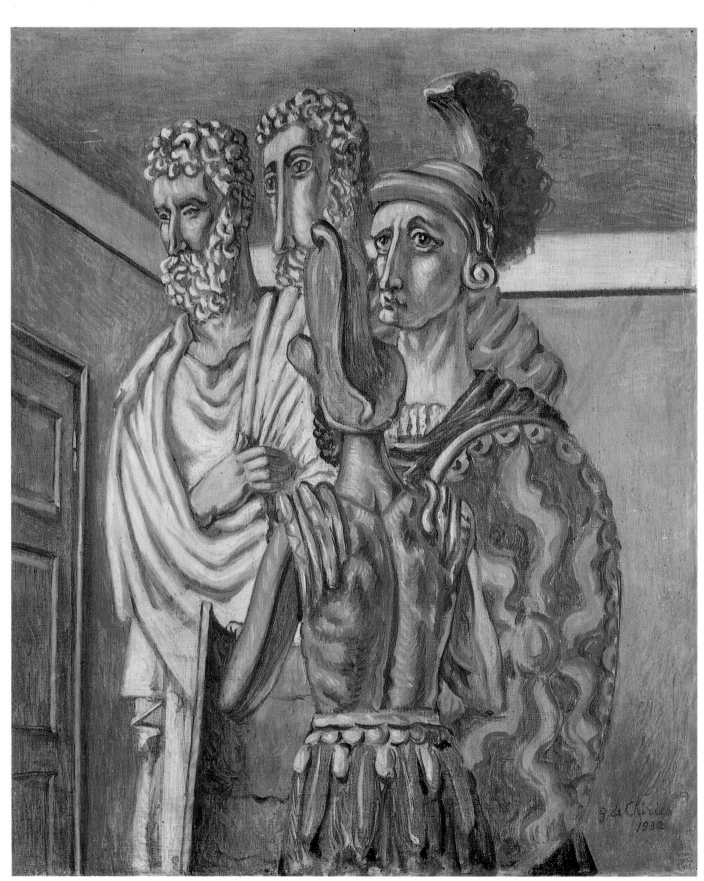

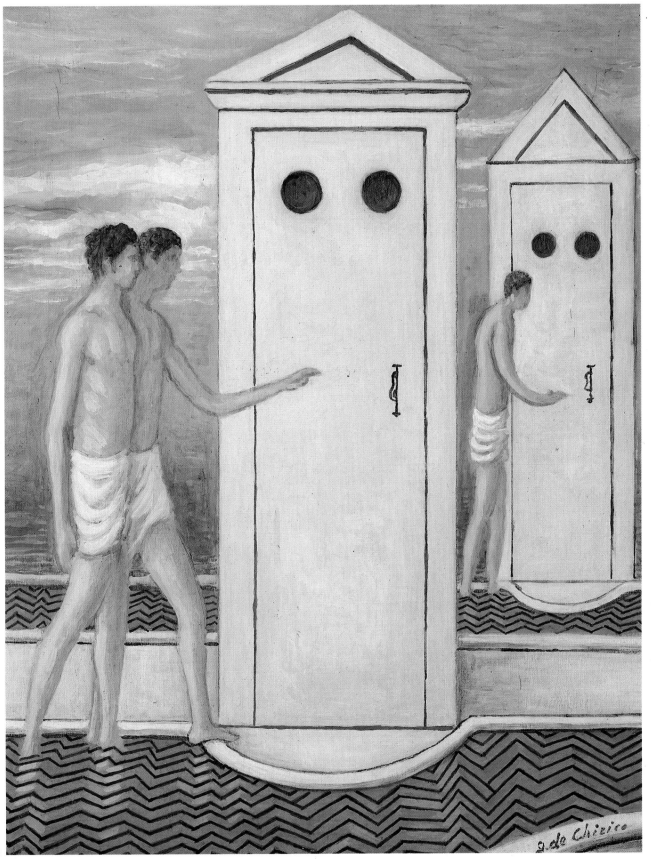

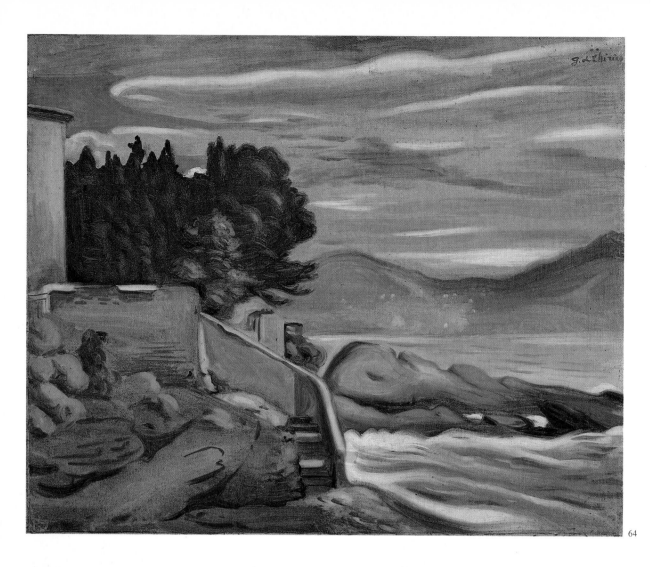

64

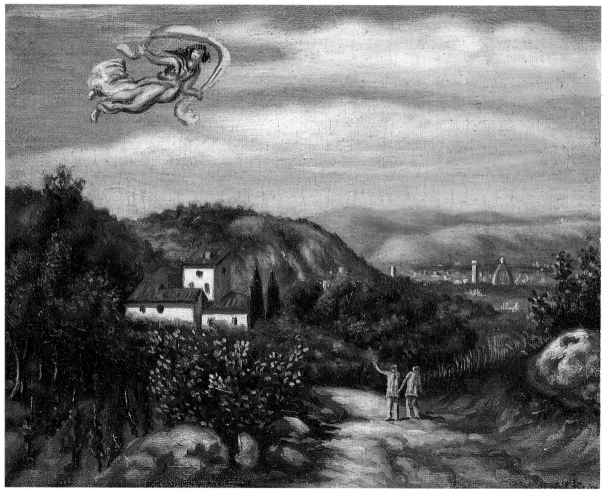

65

64. *Genova Landscape*. 1933.
 Oil on canvas, 21 × 26 in. (53 × 66 cm).
 Private Collection, Rome.

65. *Landscape with Divinity*. 1936.
 Oil on canvas, 17¼ × 14½ in. (44 × 37 cm).
 Private Collection, Rome.

66. *The Turk*. 1935.
 Oil on canvas, 15 × 17¾ in. (38 × 45 cm).
 Private Collection, Rome.

67. *The Cascine Landscape*. 1934.
 Oil on canvas, 22 × 14½ in. (56 × 37 cm).
 Private Collection, Rome.

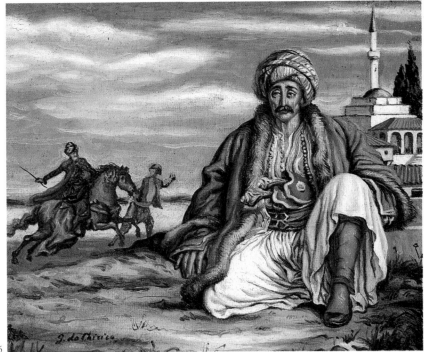

66

67

68. *Self-Portrait in the Paris Studio*. 1935.
 Oil on canvas, 51¼×30 in. (130×76 cm).
 Galleria Nazionale d'Arte Moderna, Rome.
 Isabella Pakszwer de Chirico Donation.

69. *Portrait of Isa in a Black Dress*. 1935.
 Oil on canvas, 39½×31¾ in. (100×80.5 cm).
 Galleria Nazionale d'Arte Moderna, Rome.
 Isabella Pakszwer de Chirico Donation.

70. *The Master's Studio in Paris. c.* 1933-1934.
 Oil on canvas, 21¾×18¼ in. (55.5×46.5 cm).
 Galleria Nazionale d'Arte Moderna, Rome.
 Isabella Pakszwer de Chirico Donation.

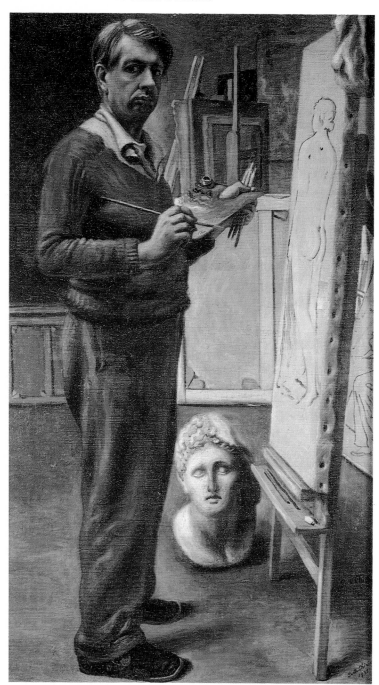

68

69

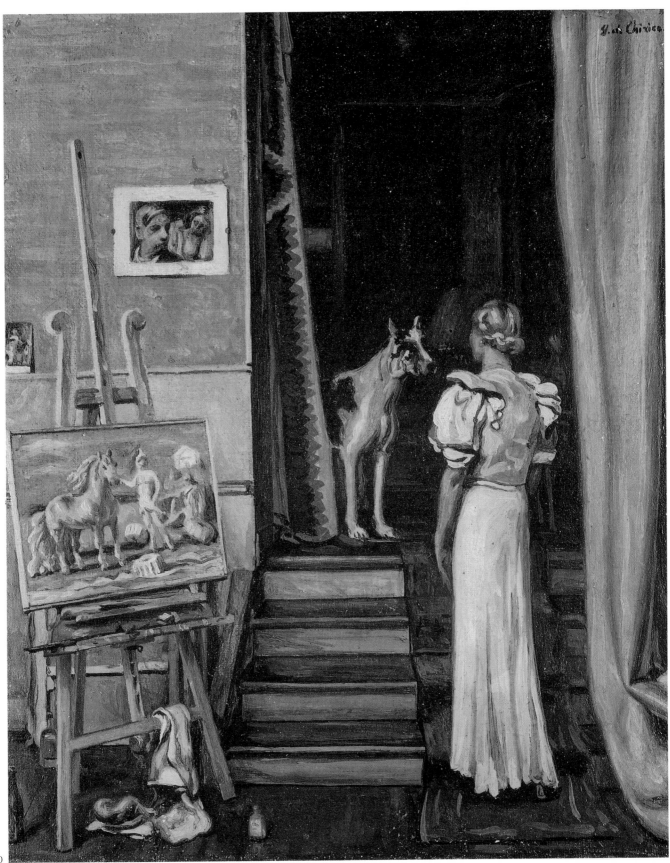

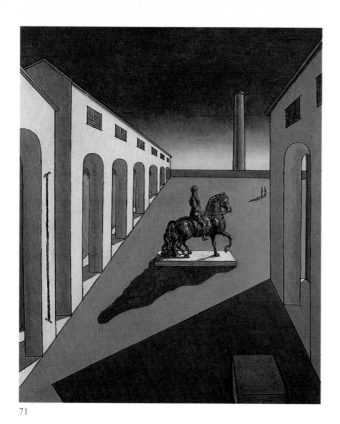

71

71. *Italian Square with Equestrian Statue*. 1936.
Oil on canvas, 23½ × 19¾ in. (60 × 50 cm).
Private Collection, Rome.

72. *Horseman with Red Cap and Blue Cape*. 1939.
Oil on paper on cardboard, 18 × 15 in. (46 × 38 cm).
Galleria Nazionale d'Arte Moderna, Rome.

73. *The Horse of the Missing Rider*. 1938.
Oil on canvas, 35 × 38½ in. (89 × 98 cm).
Private Collection, Rome.

74. *Fallen Horse*. 1941.
Oil on canvas, 21 × 18 in. (53 × 46 cm).
Private Collection, Rome.

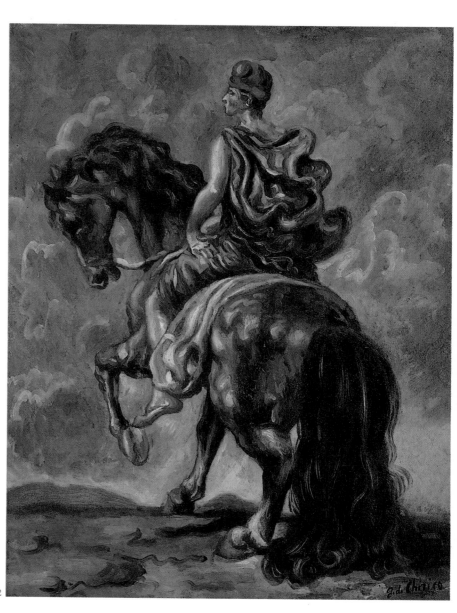

72

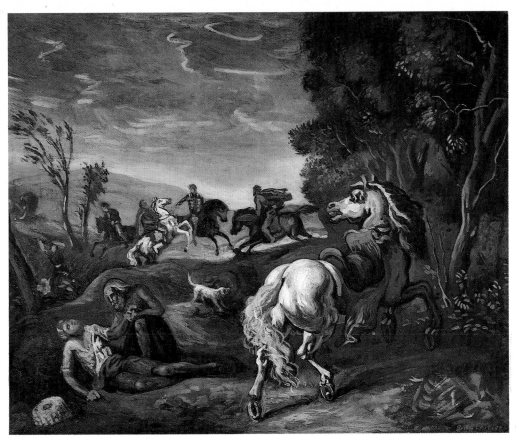

73

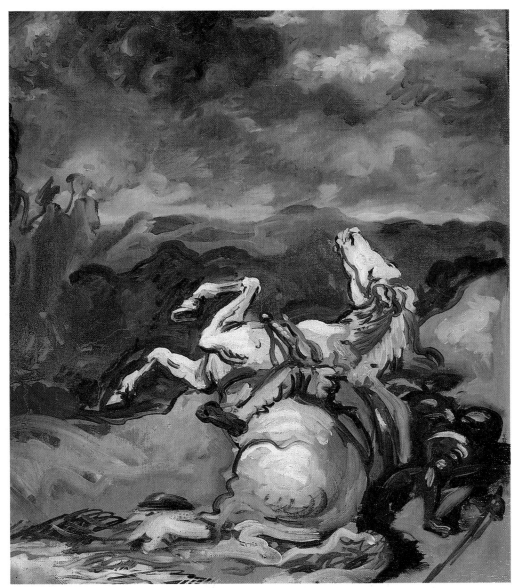

74

75

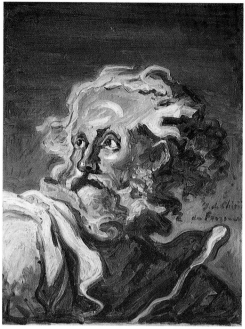

76

75. *Portrait of a Man
 (after Titian).* 1945.
 Oil on canvas,
 12¼×9 in. (31×23 cm).
 Private Collection, Rome.

76. *Head of Old Man
 (after Fragonard). c.* 1964.
 Oil on canvas,
 19¾×15¾ in. (50×40 cm).
 Private Collection, Rome.

77. *Sleeping Girl (after Watteau).* 1947.
 Oil on canvas,
 15¾×19¾ in. (40×50 cm).
 Private Collection, Rome.

78. *Nymph with Triton (after Rubens).*
 1942.
 Oil on canvas,
 15¾×19¾ in. (40×50 cm).
 Private Collection, Rome.

79. *Mythological Scene (after Rubens).*
 1960.
 Oil on canvas,
 15¾×19¾ in. (40×50 cm).
 Fondazione Giorgio e Isa de Chirico,
 Rome.
 Isabella Pakszwer de Chirico
 Donation.

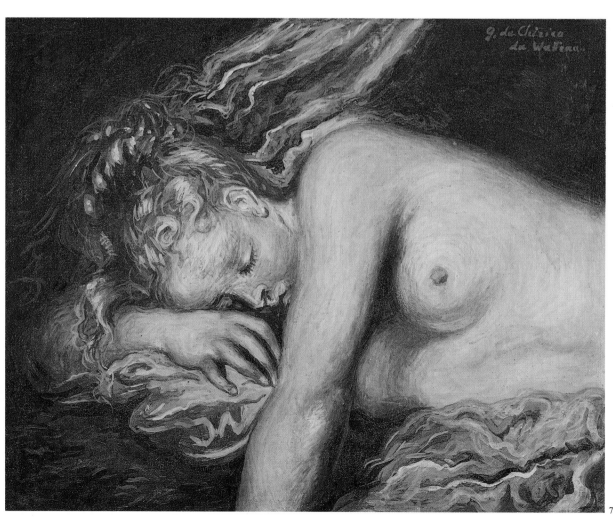

77

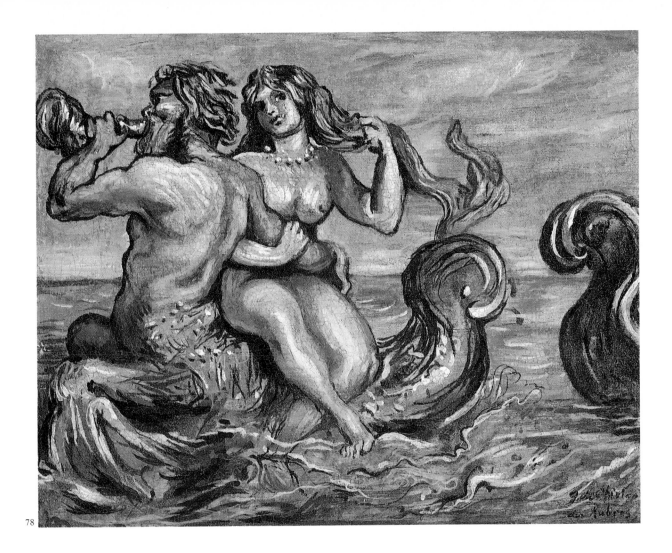

78

79

80. *Phaeton's Fall (after Rubens)*. 1954.
 Oil on canvas, 19¾×15¼ in. (50×40 cm).
 Private Collection, Rome.

81. *Portrait of Isa with Rose in the Park*. 1938.
 Oil on canvas, 42½×33½ in. (108×85 cm).
 Private Collection, Rome.

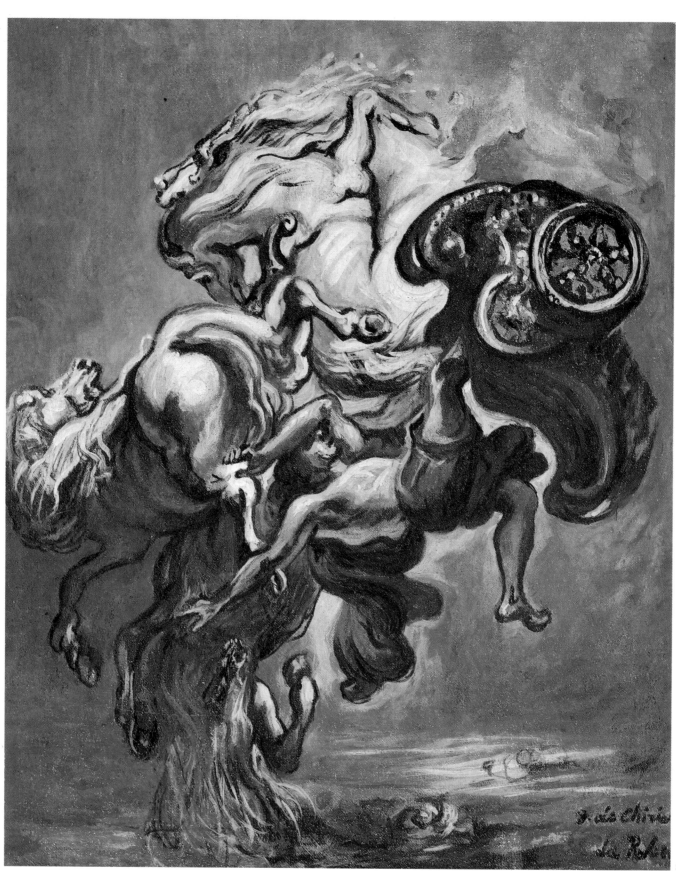

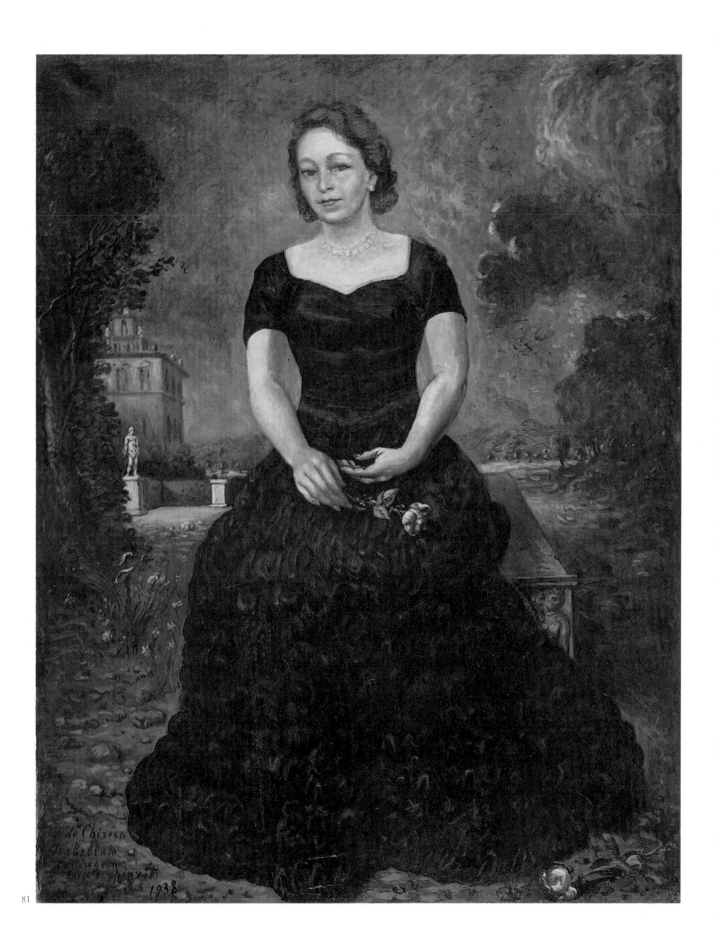

81

82. *The Colonial Dummies.* 1943.
 Oil on canvas, 32¾ × 21 in. (83 × 53 cm).
 Private Collection.

83. *Italian Square with Red Tower.* 1943.
 Oil on canvas, 19¾ × 15¾ in. (50 × 40 cm).
 Private Collection, Rome.

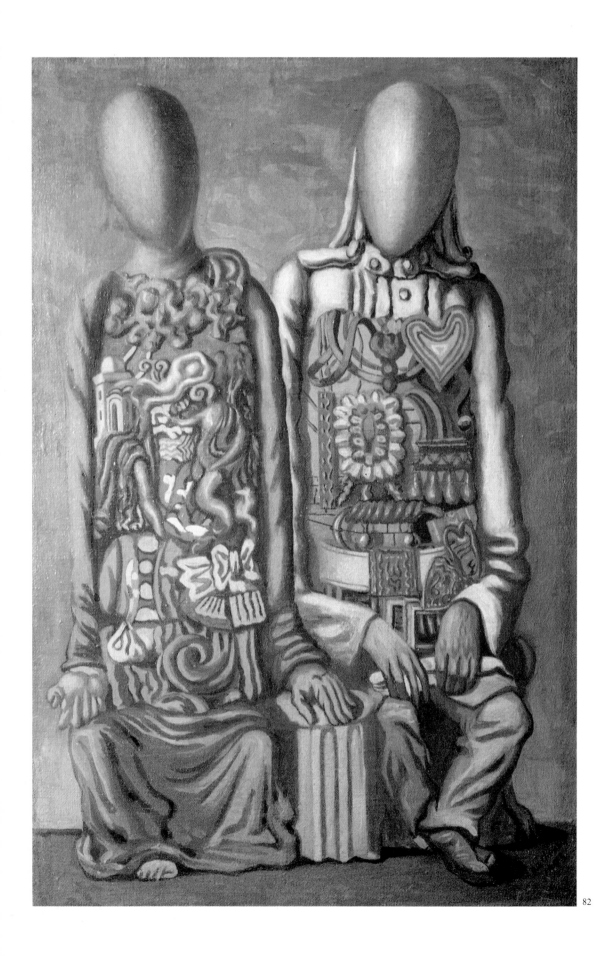

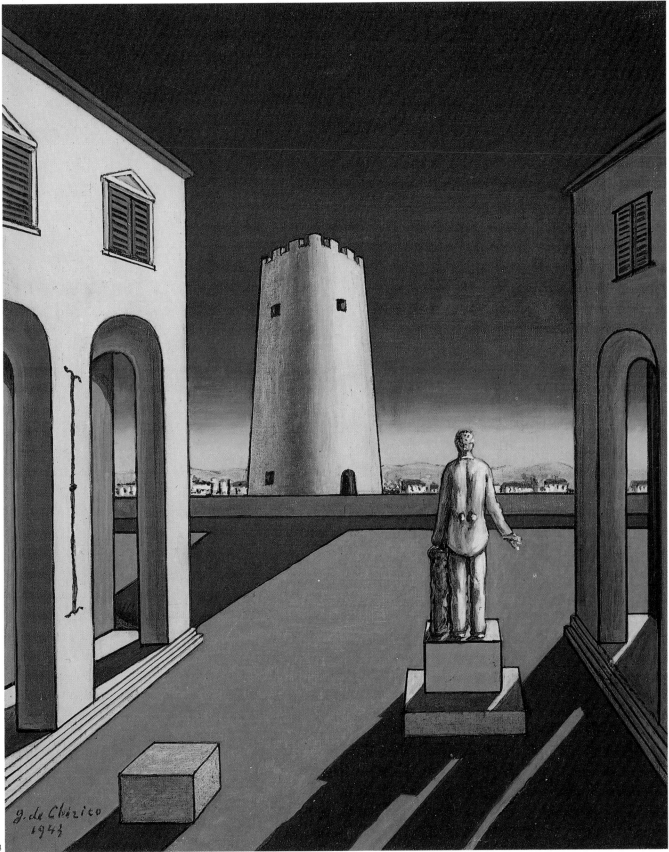

84. *Self-Portrait in the Nude*. 1945 (or 1942).
 Oil on canvas, 23¾ × 19¾ in. (60.5 × 50 cm).
 Galleria Nazionale d'Arte Moderna, Rome.
 Isabella Pakszwer de Chirico Donation.

85. *Self-Portrait in the Nude*. 1945.
 Oil on canvas, 22 × 16½ in. (56 × 42 cm).
 Fondazione Giorgio e Isa de Chirico, Rome.
 Isabella Pakszwer de Chirico Donation.

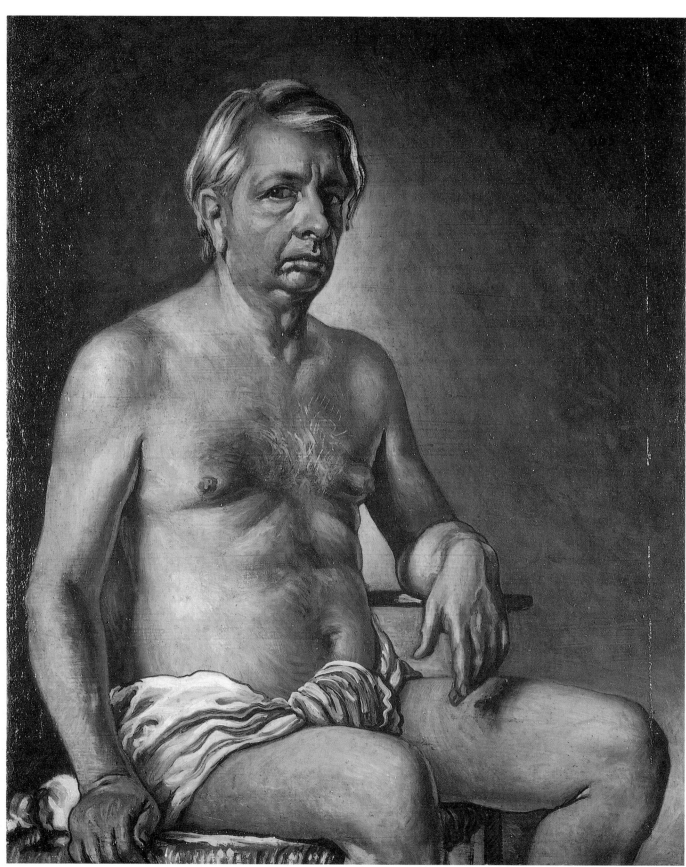

84

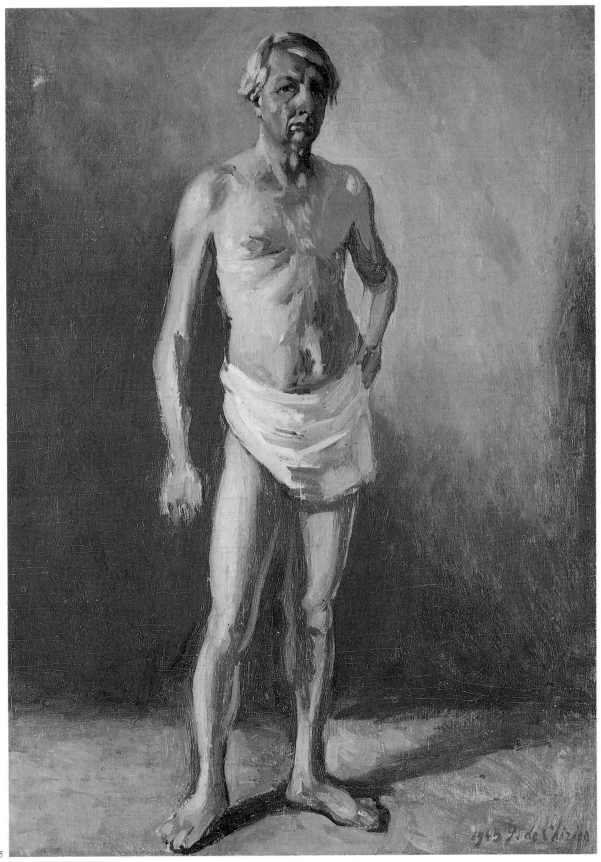

86. *Landscape with Village. c.* 1940.
 Oil on canvas, 13½ × 21½ in. (35 × 55 cm).
 Private Collection, Rome.

87. *Villa Falconieri.* 1946.
 Oil on canvas, 15¾ × 19¾ in. (40 × 50 cm).
 Private Collection, Rome.

88. *Villa Medici: Pavilion with Statue.* 1945.
 Oil on canvas, 23½ × 17¼ in. (60 × 44 cm).
 Private Collection, Rome.

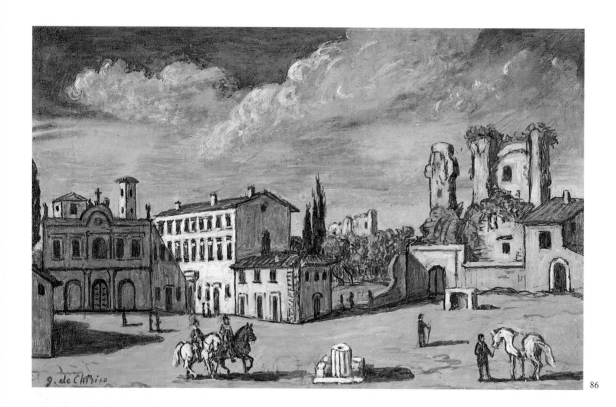

86

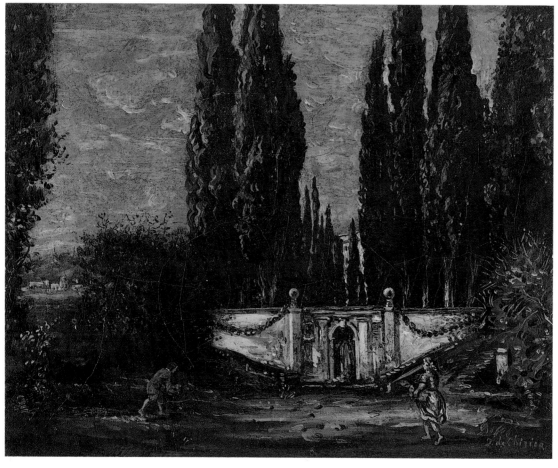

87

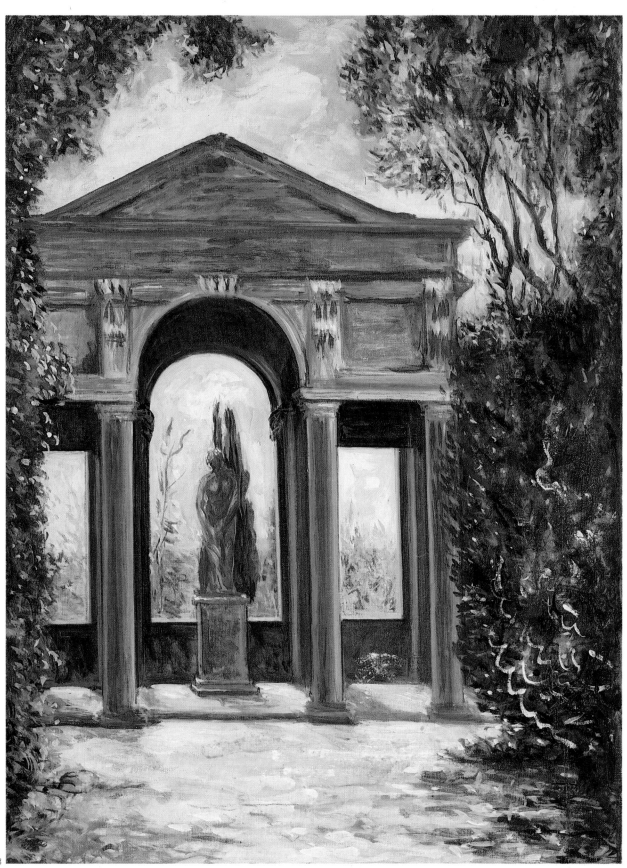

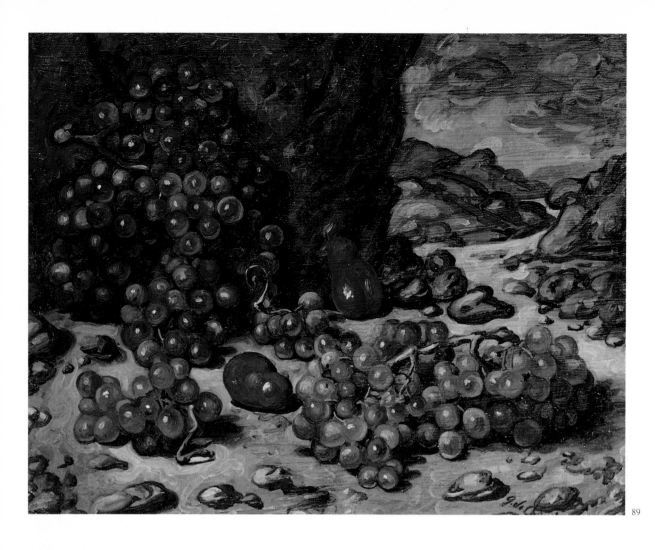

89

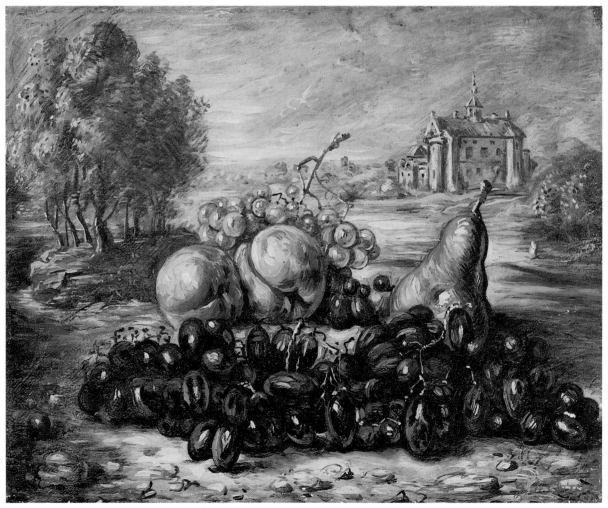

90

89. *Still Life with Rocky Landscape.* 1942.
 Oil on canvas, 14¼ × 17¾ in. (36 × 45 cm).
 Private Collection, Rome.

90. *Black Grape (Still Life with Landscape).* 1947.
 Oil on canvas, 15¾ × 19¾ in. (40 × 50 cm).
 Private Collection, Rome.

91. *Silent Life with Venetian Landscape.*
 c. 1952.
 Oil on canvas, 19¾ × 23½ in. (50 × 60 cm).
 Private Collection, Rome.

92. *Bust of Minerva.* 1947.
 Oil on canvas, 23½ × 19¾ in. (60 × 50 cm).
 Private Collection, Rome.

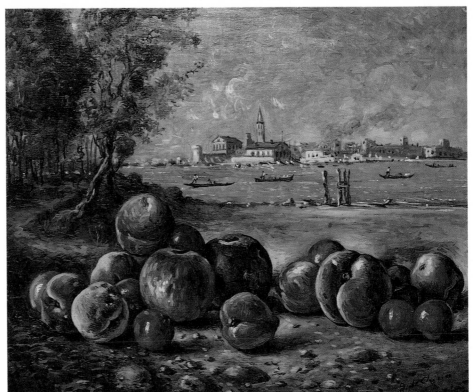

91

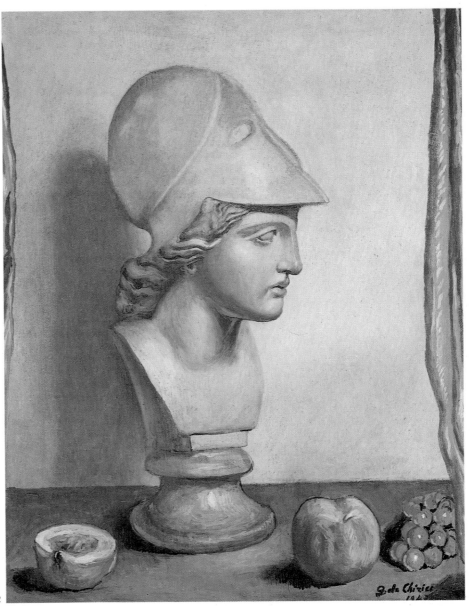

92

93. *Self-Portrait in Seventeenth-Century Costume*. 1947.
Oil on canvas, 32½ × 23¼ in. (82.5 × 59 cm).
Galleria Nazionale d'Arte Moderna, Rome.
Isabella Pakszwer de Chirico Donation.

94. *Self-Portrait*. 1948.
Oil on canvas, 15¾ × 11¾ in. (40 × 30 cm).
Private Collection.

95. *Self-Portrait*. 1949.
Oil on canvas, 7¾ × 5½ in. (19.5 × 14 cm).
Private Collection, Trieste.

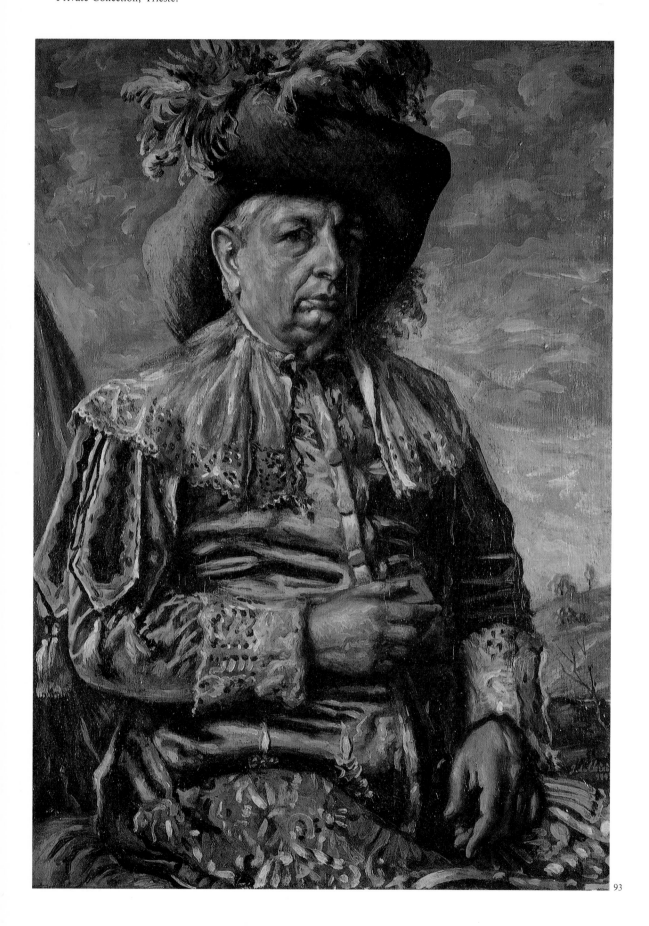

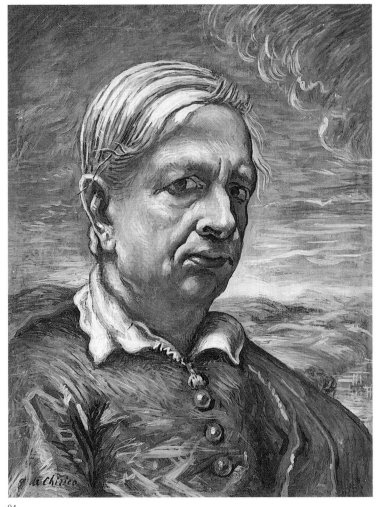

94

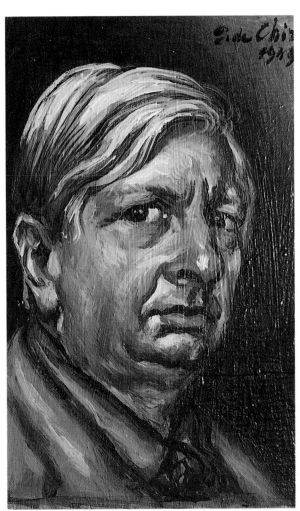

95

96. *Castor and his Horse*. 1947.
 Oil on canvas, 24×31 in. (61×79 cm).
 Private Collection, Rome.

97. *Horses with Temple*. 1949.
 Oil on canvas, 19×22¾ in. (48×58 cm).
 Private Collection.

98. *Dioscurus and Horse*. 1949.
 Oil on canvas, 24×31 in. (61×79 cm).
 Private Collection, Rome.

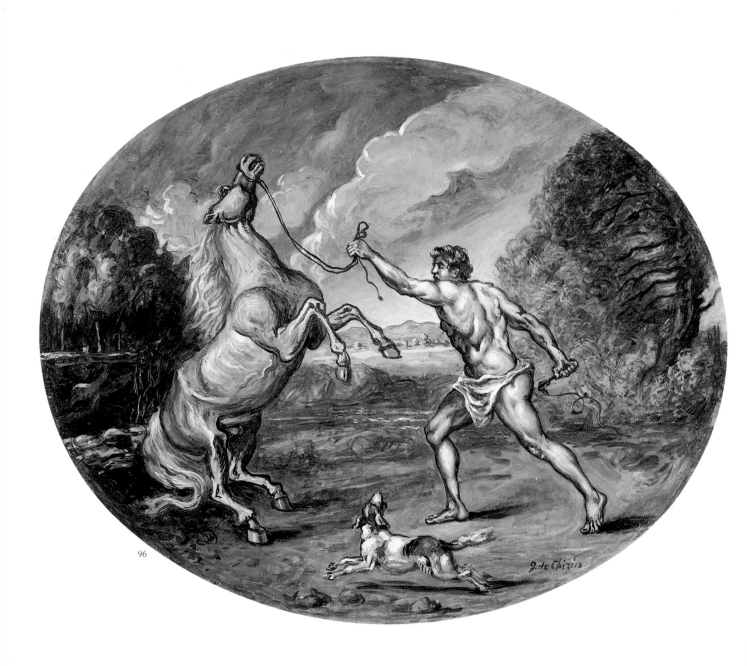

96

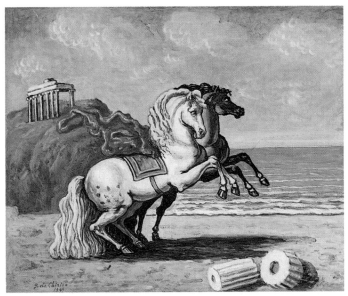

97

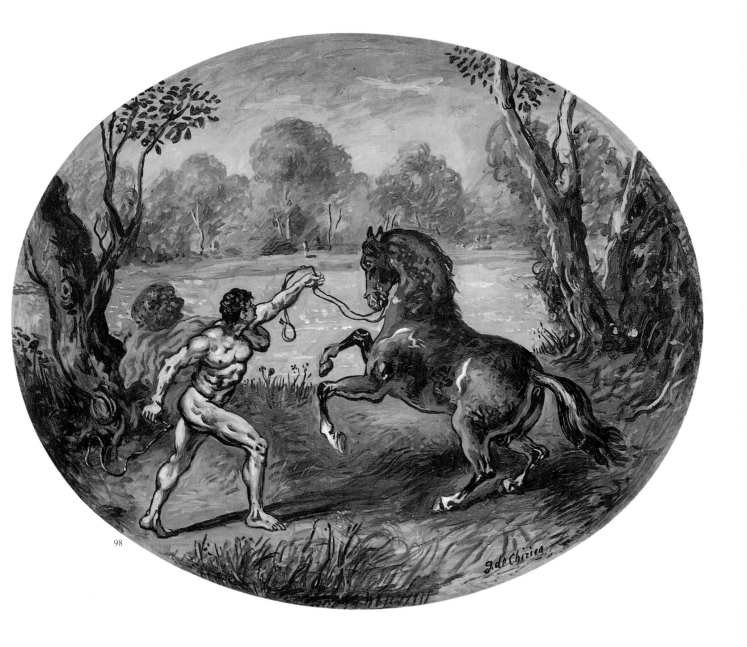

98

99. *The Fall.* c. 1947-1954.
 Oil on canvas, 72¾×63 in. (185×160 cm).
 Private Collection, Rome.

100. *The Tournament.* 1952.
 Oil on canvas, 23½×31½ in. (60×80 cm).
 Private Collection, Rome.

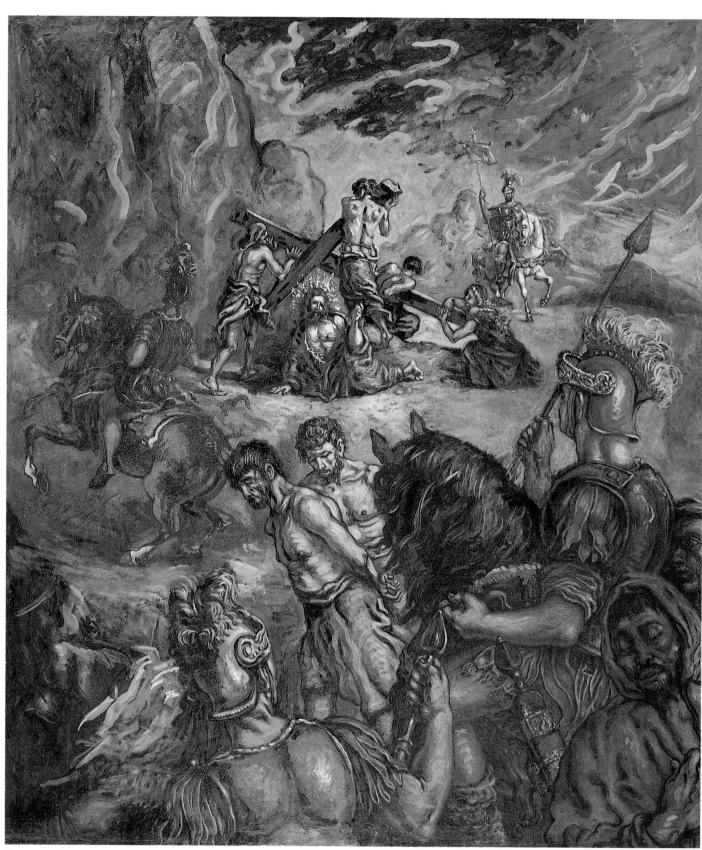

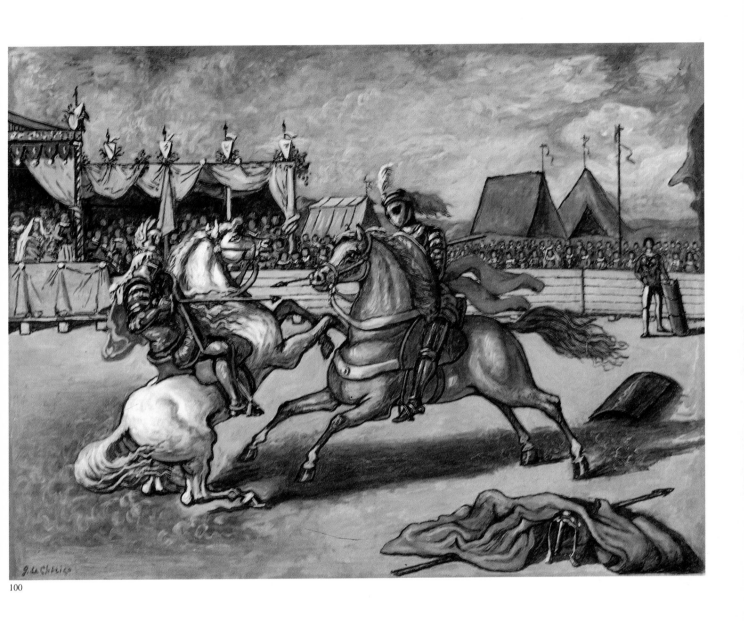

101. *Hector and Andromache.* 1946.
 Oil on canvas, 32¼ × 23½ in. (82 × 60 cm).
 Private Collection, Rome.

102. *Metaphysical Interior with Workshop.* 1948.
 Oil on canvas, 25½ × 21 in. (64.5 × 53.5 cm).
 Private Collection, Rome.

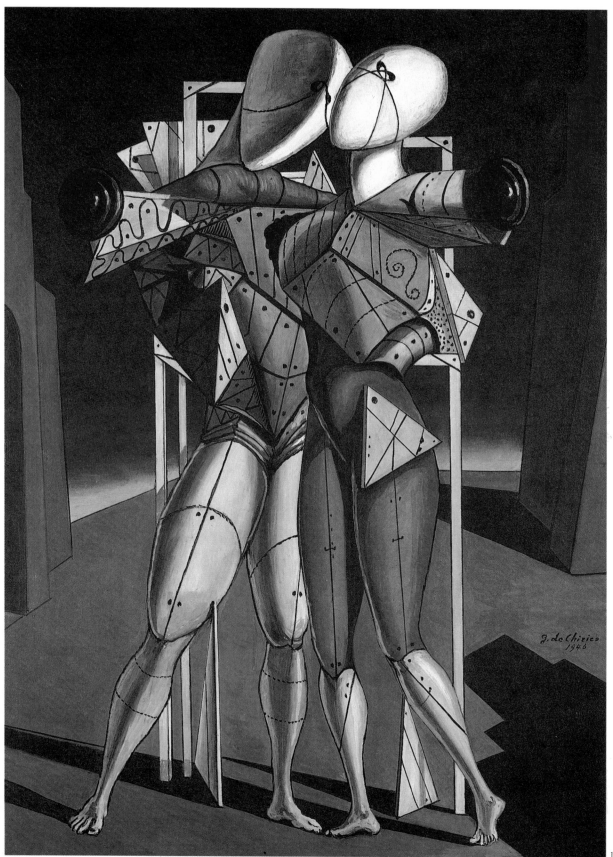

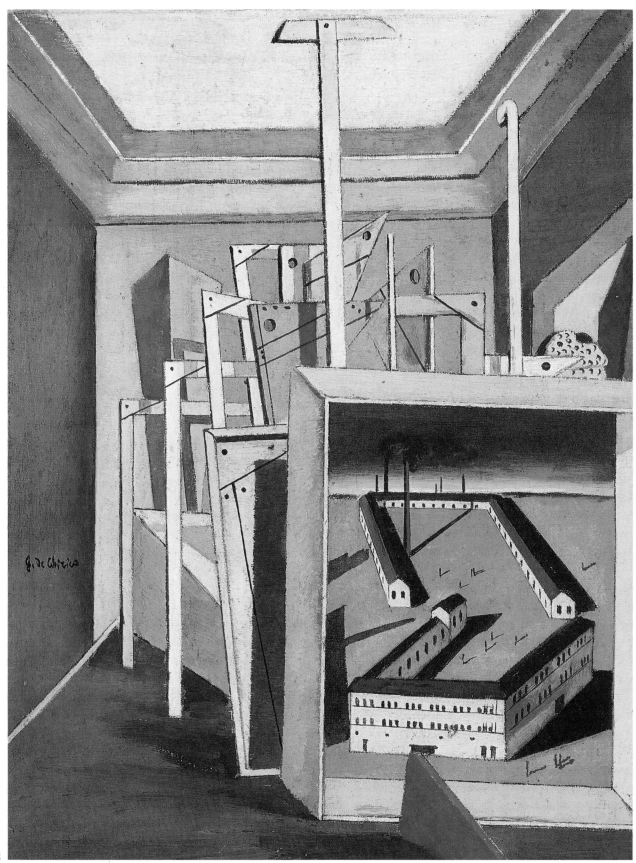

103. *The Italian Beauty*. 1952.
Oil on canvas, 34½ × 31½ in. (88 × 80 cm).
Private Collection, Rome.

104. *Naiads Bathing*. 1955.
Oil on canvas, 32¼ × 42½ in. (82 × 108 cm).
Private Collection, Rome.

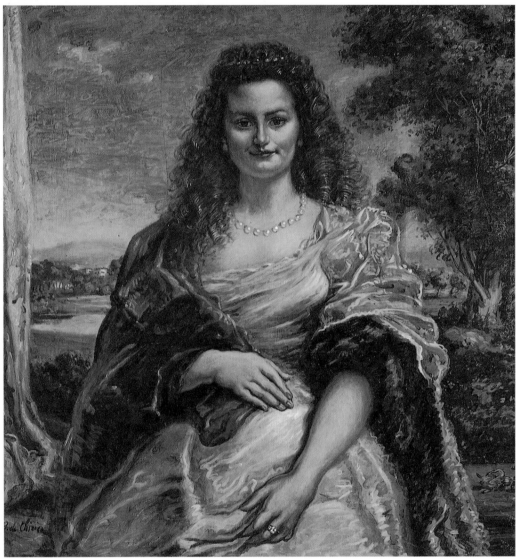

103

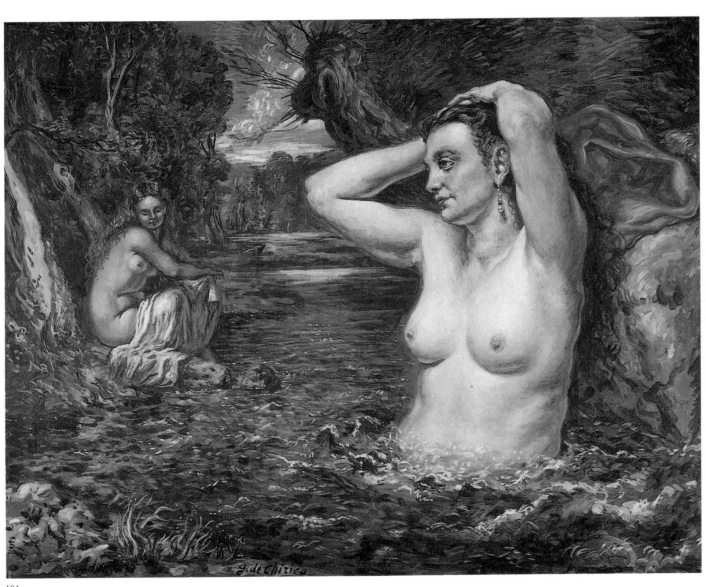

104

105. *Self-Portrait in Black Costume*. 1948.
Oil on canvas, 60 × 35¼ in. (152.5 × 89.5 cm).
Galleria Nazionale d'Arte Moderna, Rome.
Isabella Pakszwer de Chirico Donation.

106. *Self-Portrait in Seventeenth-Century Costume*
(or *Self-Portrait in a Park*). 1959.
Oil on canvas, 60¼ × 38½ in. (153 × 98 cm).
Private Collection, Rome.

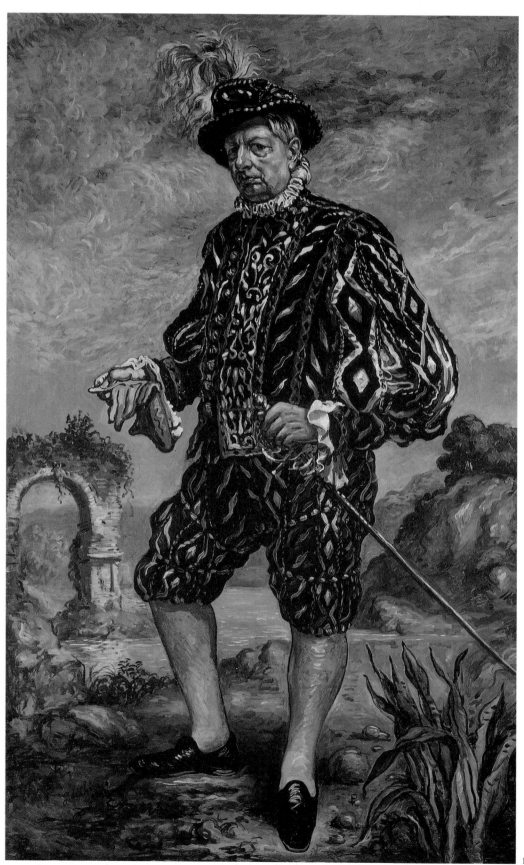

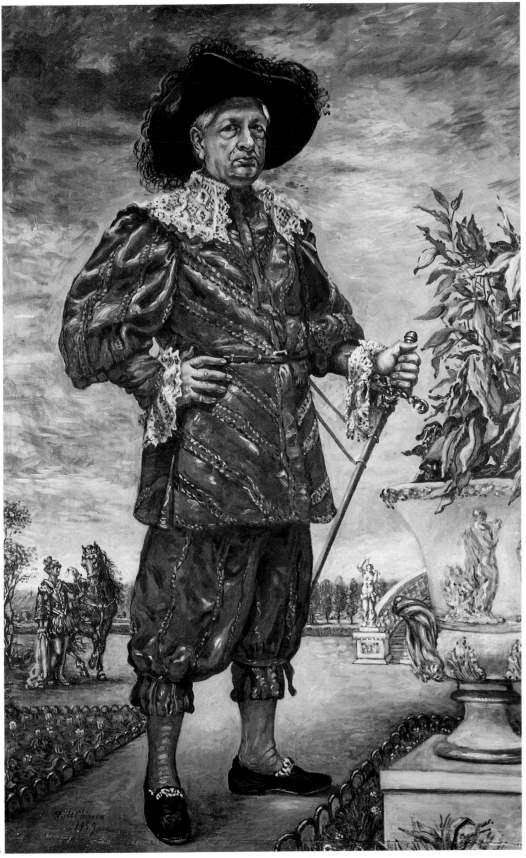

107. *Cake with Silver Teapot. c.* 1952.
Oil on canvas, 19¾ × 23½ in. (50 × 60 cm).
Private Collection, Trieste.

108. *Silver Objects* or *Silent Still Life with Silver Crockery.* 1962.
Oil on canvas, 54¼ × 76 in. (138 × 193 cm).
Private Collection.

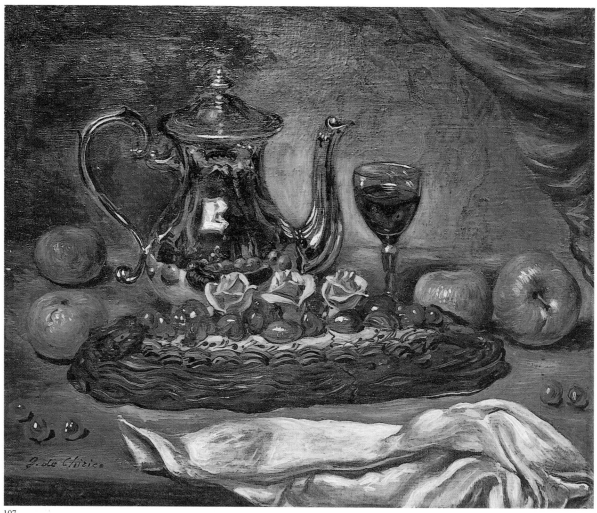

107

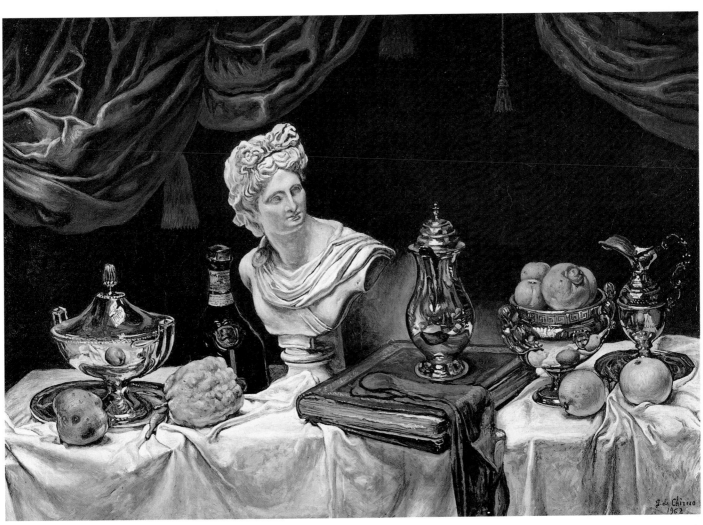

108

109. *Gladiators' School.* 1953.
Oil on canvas, 39½ × 31½ in. (100 × 80 cm).
Private Collection, Rome.

110. *He who Comforts. c.* 1960.
Oil on canvas, 39½ × 32 in. (100 × 81 cm).
Private Collection, Rome.

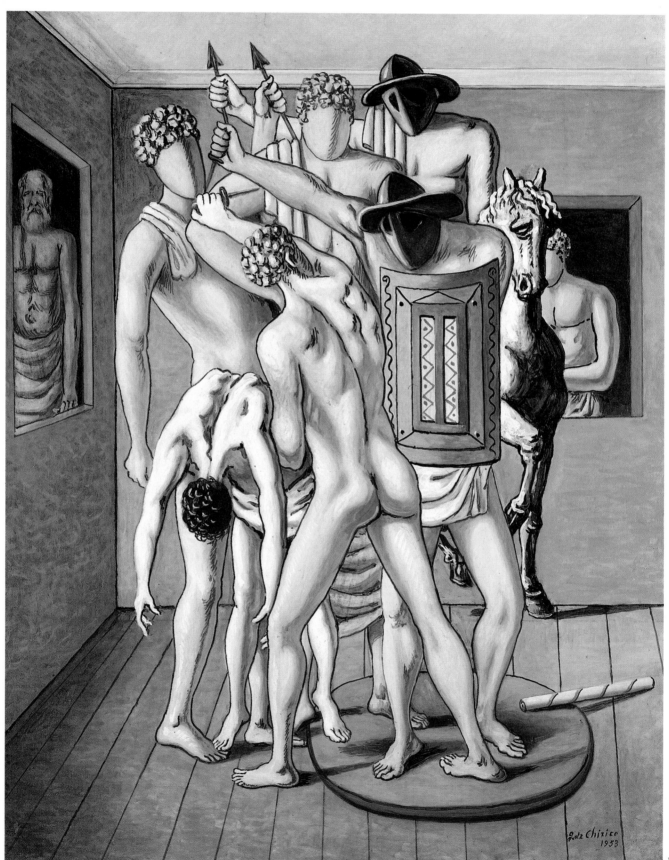

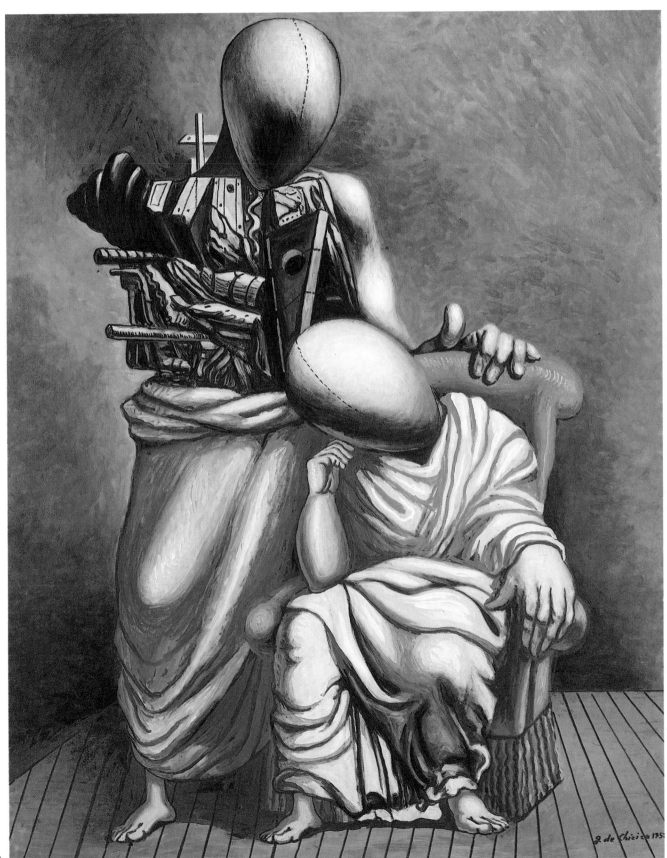

111

112

111. *The Via Appia. c.* 1954.
 Oil on canvas, 17 × 21¼ in. (43 × 54 cm).
 Private Collection, Rome.

112. *Florence: The Arno.* 1957.
 Oil on canvas, 17 × 21¼ in. (43 × 54 cm).
 Private Collection, Rome.

113. *St George's Island.* 1957.
 Oil on canvas, 19¼ × 22¾ in. (49 × 58 cm).
 Private Collection, Rome.

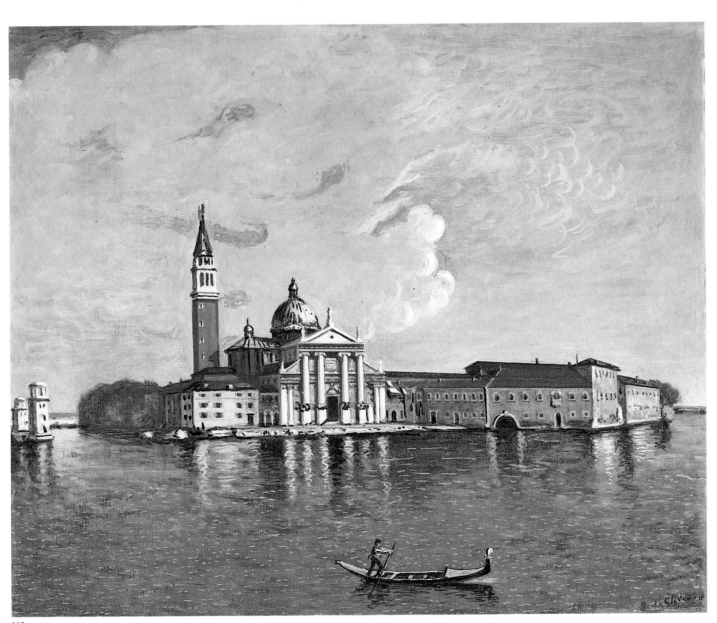

113

114. *Metaphysical Interior with Biscuits.* 1958.
Oil on canvas, 25½ × 19¾ in. (65 × 50 cm).
Private Collection, Rome.

115. *The Red Glove.* 1958.
Oil on canvas, 28¼ × 19 in. (72 × 48 cm).
Private Collection, Rome.

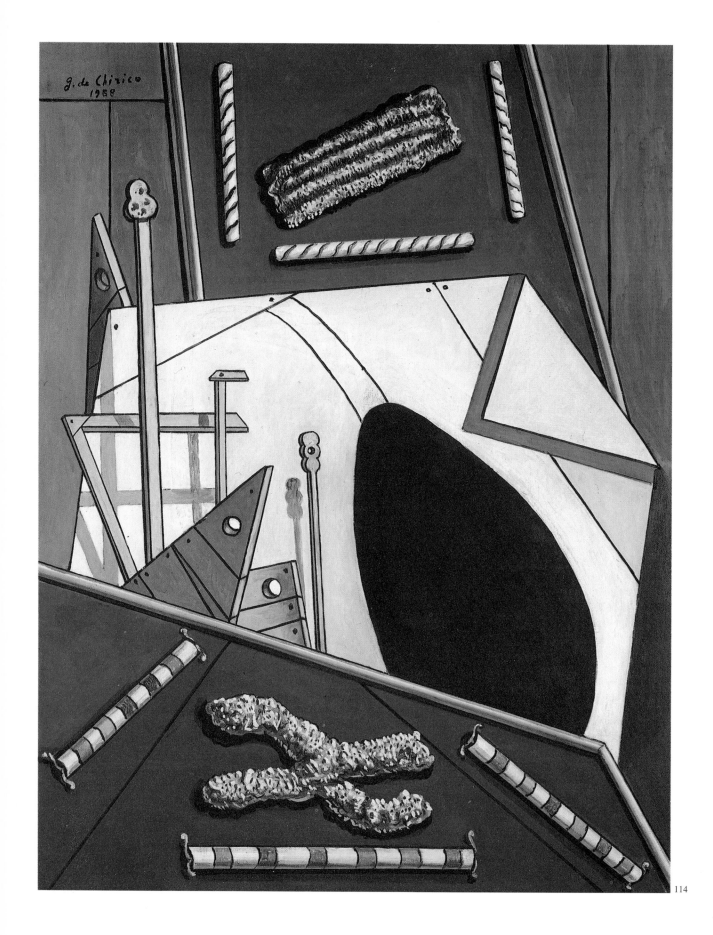

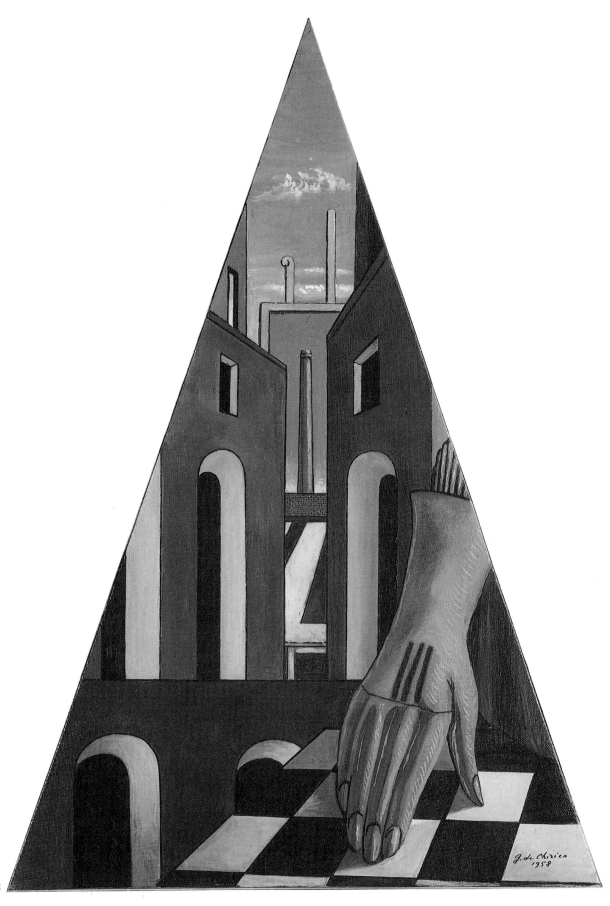

116. *Flowers in a Copper Pot.* 1960-1968.
Oil on canvas, 35½×31½ in. (90×80 cm).
Private Collection, Rome.

117. *Island with a Garland of Flowers.* 1969.
Oil on cardboard, 19¾×23½ in. (50×60 cm).
Private Collection, Rome.

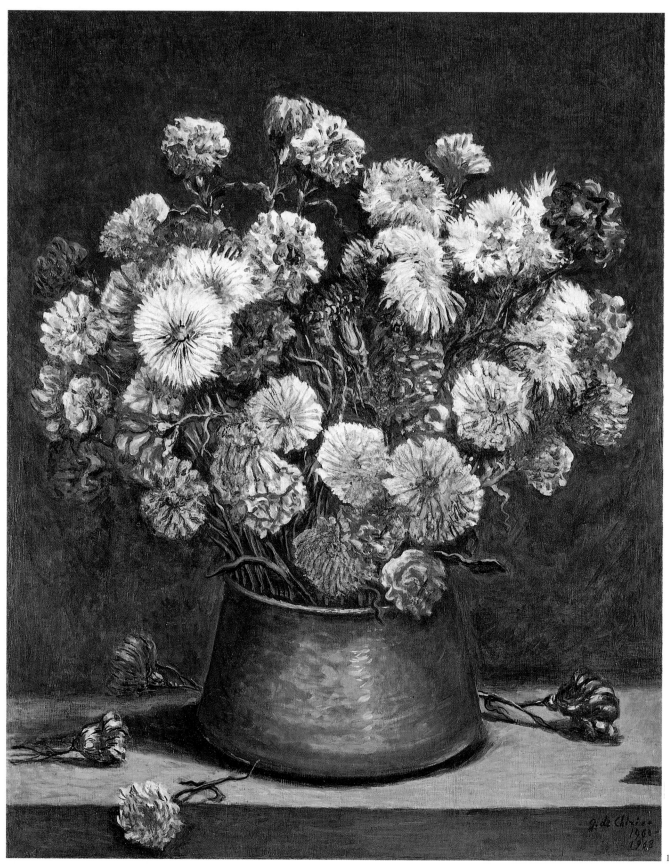

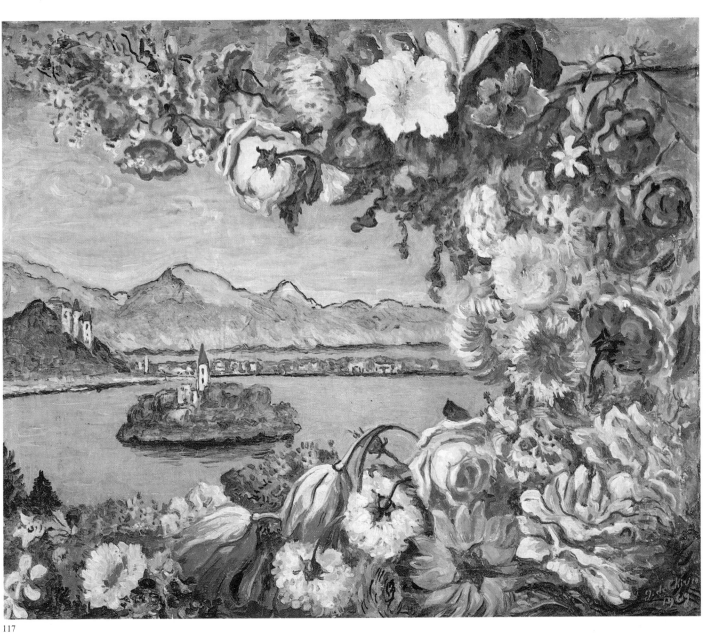

117

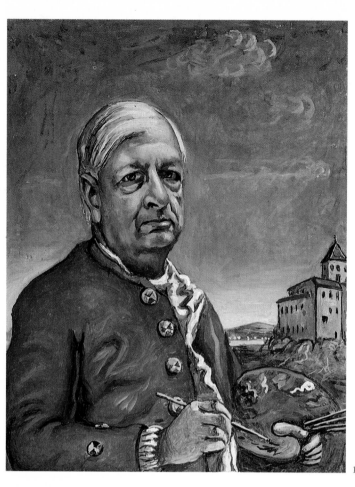

118. *Self-Portrait with Palette*. 1960.
 Oil on cardboard, 17¾ × 11¾ in. (45 × 30 cm).
 Private Collection, Rome.

119. *Horsemen and Horses by the Sea. c*. 1960.
 Oil on canvas, 30 × 42 in. (76 × 107 cm).
 Private Collection, Rome.

120. *Head of White Horse with Mane Blowing in the Wind*. 1959.
 Oil on canvas, 19¾ × 15¾ in. (50 × 40 cm).
 Private Collection, Rome.

121. *Country Scene with Landscape. c*. 1960.
 Oil on canvas, 42 × 30 in. (107 × 76 cm).
 Private Collection, Rome.

118

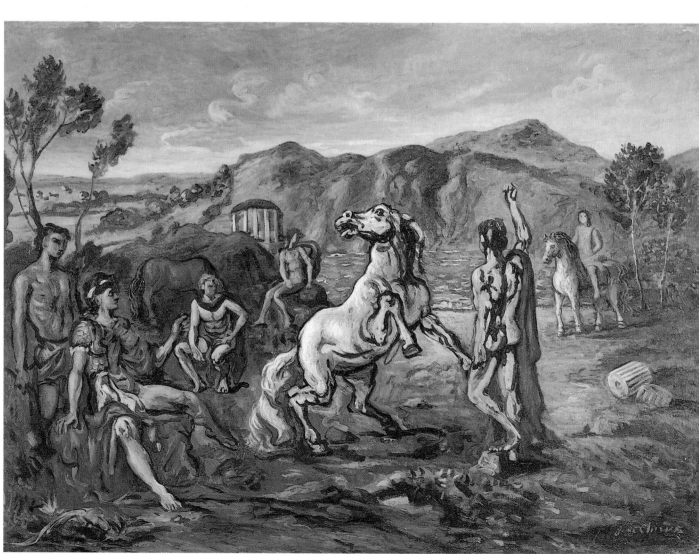

120

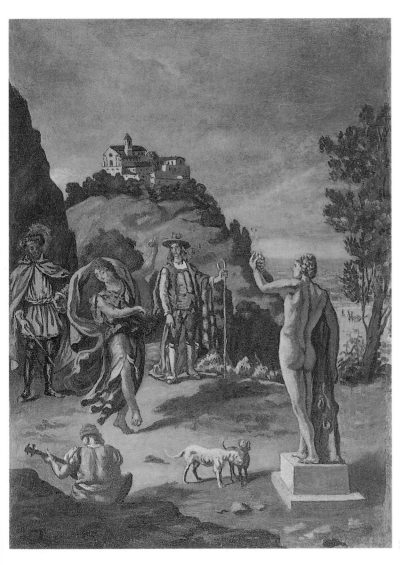

121

122. *The Divine Horses of Achilles: Balios and Xanthos*. 1963.
Oil on canvas, 38½ × 34½ in. (98 × 87 cm).
Private Collection, Rome.

123. *The Intruder. c.* 1970.
Oil on canvas, 15¼ × 19¾ in. (40 × 50 cm).
Private Collection, Rome.

124. *Apollo's Horses*. 1974.
Oil on canvas, 36½ × 28¾ in. (92.5 × 73 cm).
Private Collection, Rome.

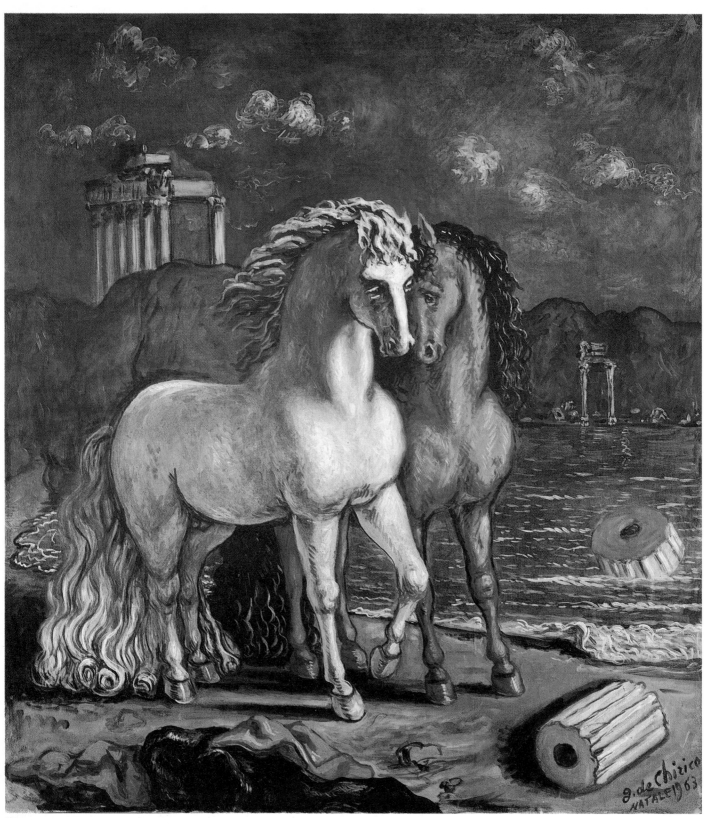

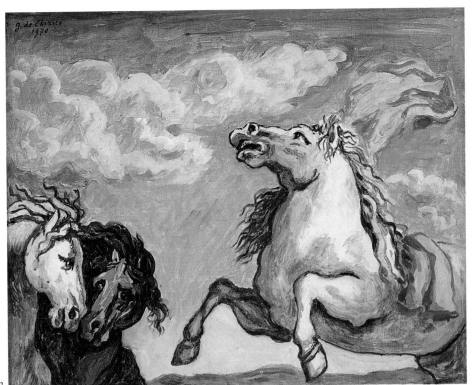

123

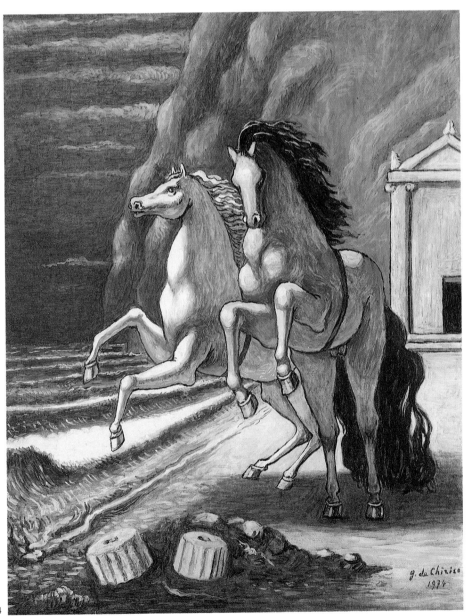

124

125. *Ulysses' Return*. 1968.
Oil on canvas, 23½ × 31½ in. (60 × 80 cm).
Private Collection, Rome.

126. *Mysterious Baths. Flight to the Sea*. 1968.
Oil on canvas, 31½ × 23½ in. (80 × 60 cm).
Private Collection, Rome.

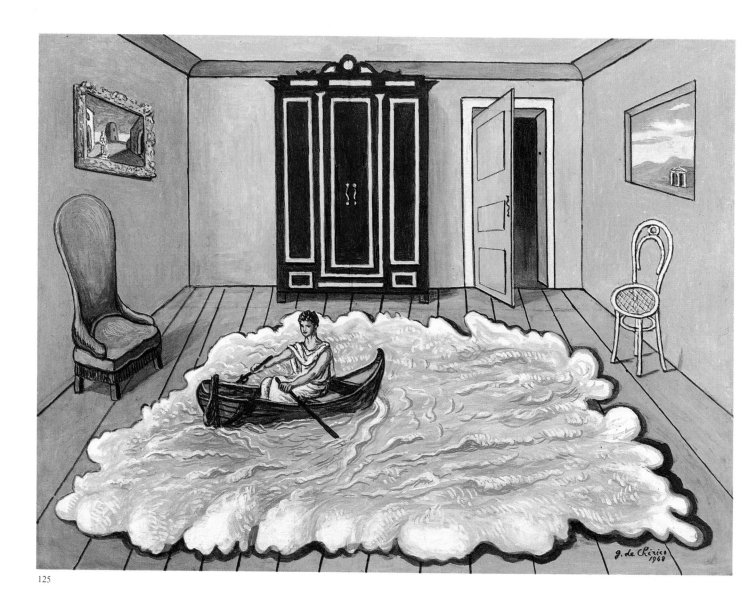

125

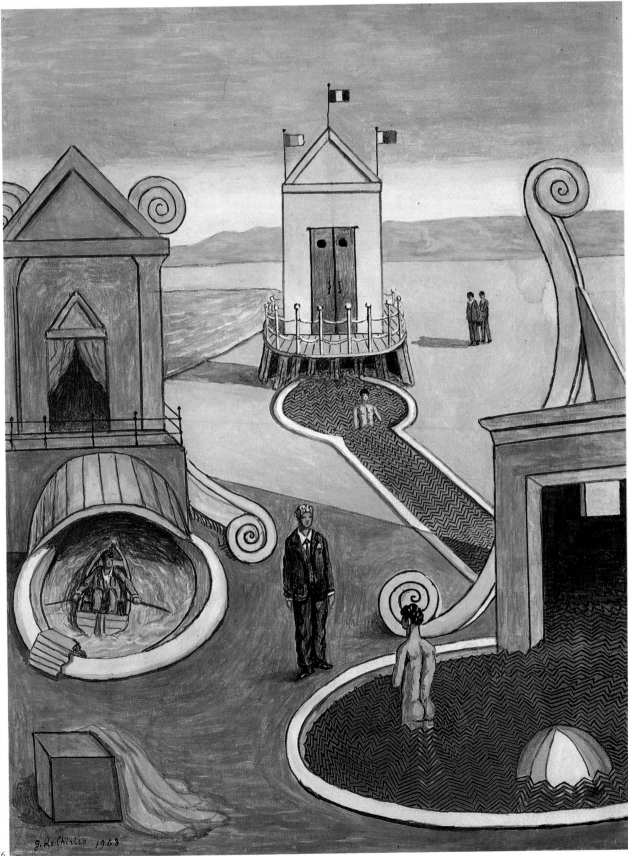

127. *Metaphysical Interior with Setting Sun*. 1971.
Oil on canvas, 31½ × 23½ in. (80 × 60 cm).
Private Collection, Rome.

128. *Sun Rising over the Square*. 1971.
Oil on canvas, 19¾ × 27½ in. (50 × 70 cm).
Private Collection, Rome.

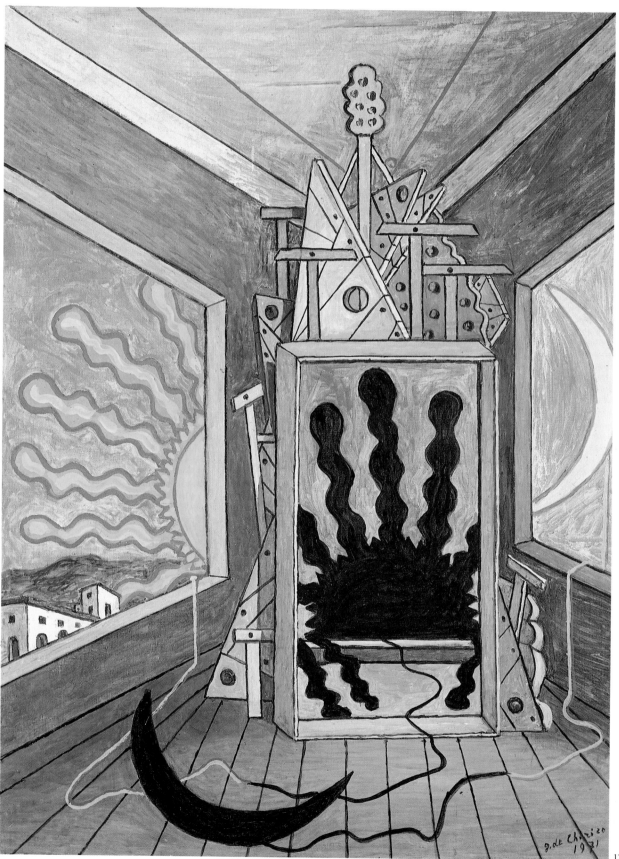

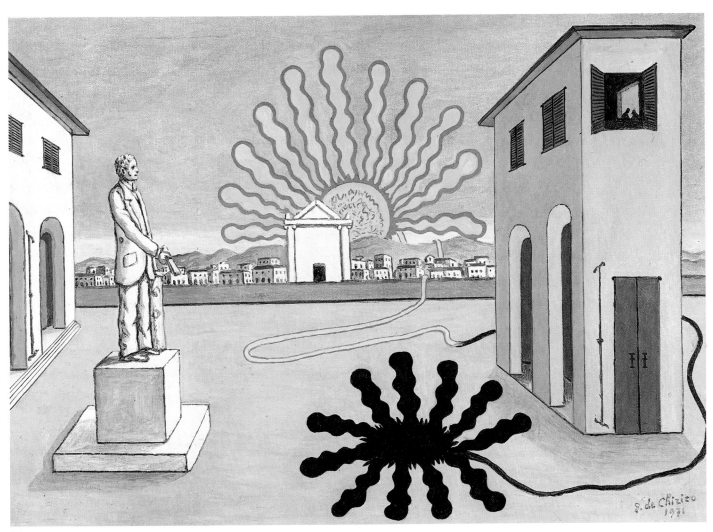

128

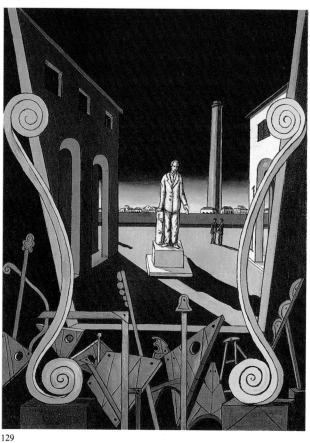

129

129. *Italian Square with Monument to the Poet*. 1969.
Oil on canvas, 31½ × 23½ in. (80 × 60 cm).
Private Collection, Rome.

130. *The Great Game (Italian Square)*. 1971.
Oil on canvas, 23½ × 31½ in. (60 × 80 cm).
Private Collection, Paris.

131. *The Dioscuri*. 1974.
Oil on canvas, 35¾ × 28¼ in. (91 × 72 cm).
Private Collection, Paris.

132. *The Masks*. 1974.
Oil on canvas, 23½ × 19¾ in. (60 × 50 cm).
Private Collection, Rome.

130

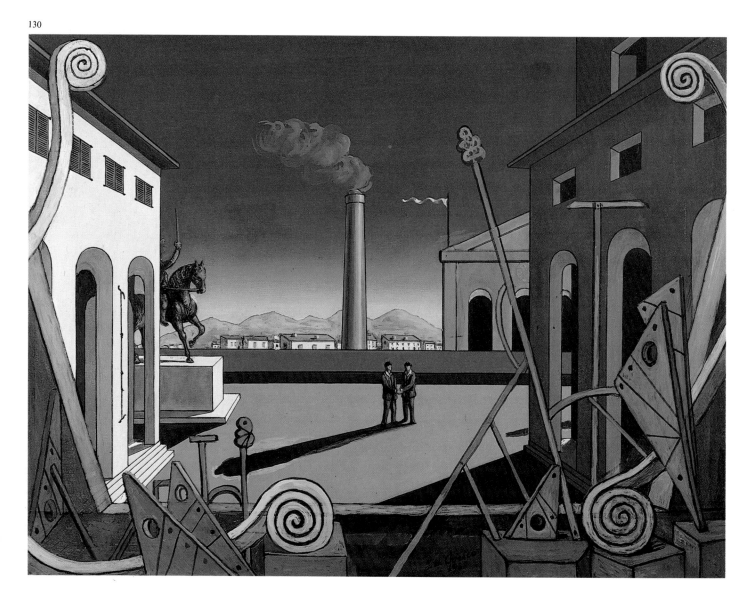

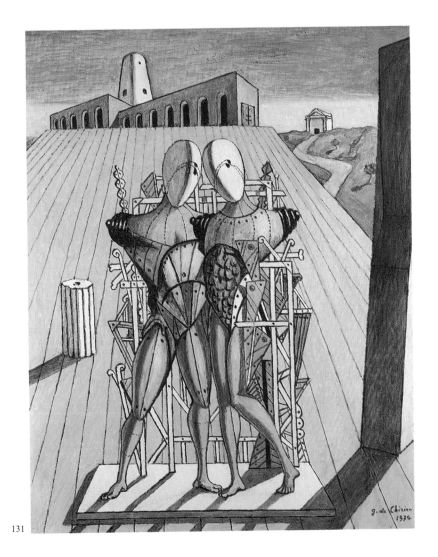

131

132

133. *The Muse of Silence*. 1973.
Oil on canvas, 36¼ × 28¾ in. (92 × 73 cm).
Private Collection, Rome.

134. *Furniture and Rocks in a Room*. 1973.
Oil on canvas, 39½ × 32 in. (100 × 81 cm).
Private Collection, Rome.

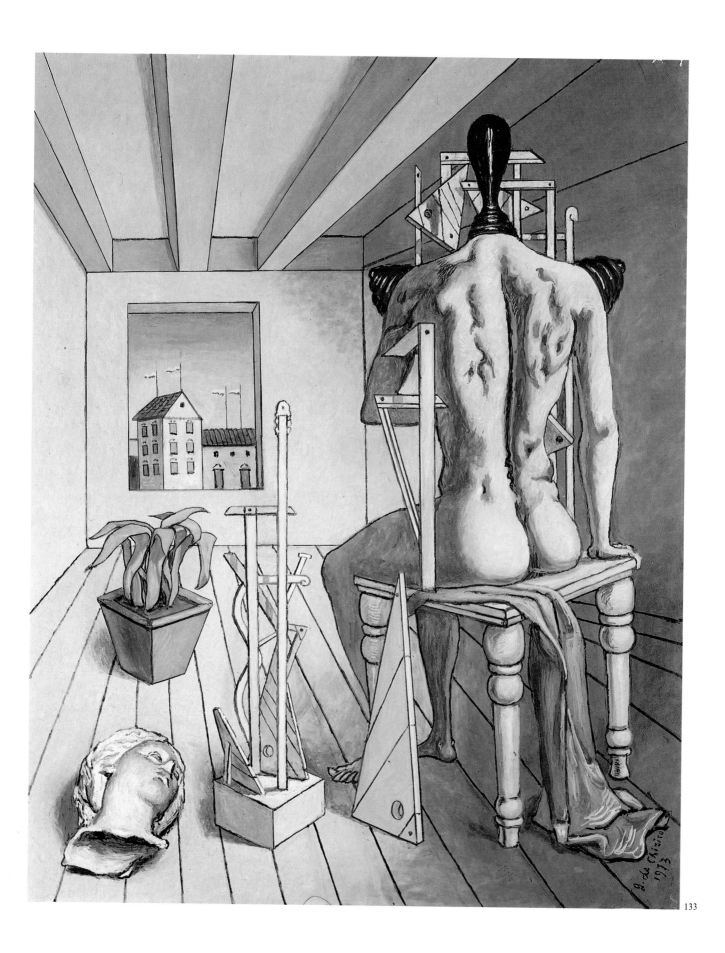

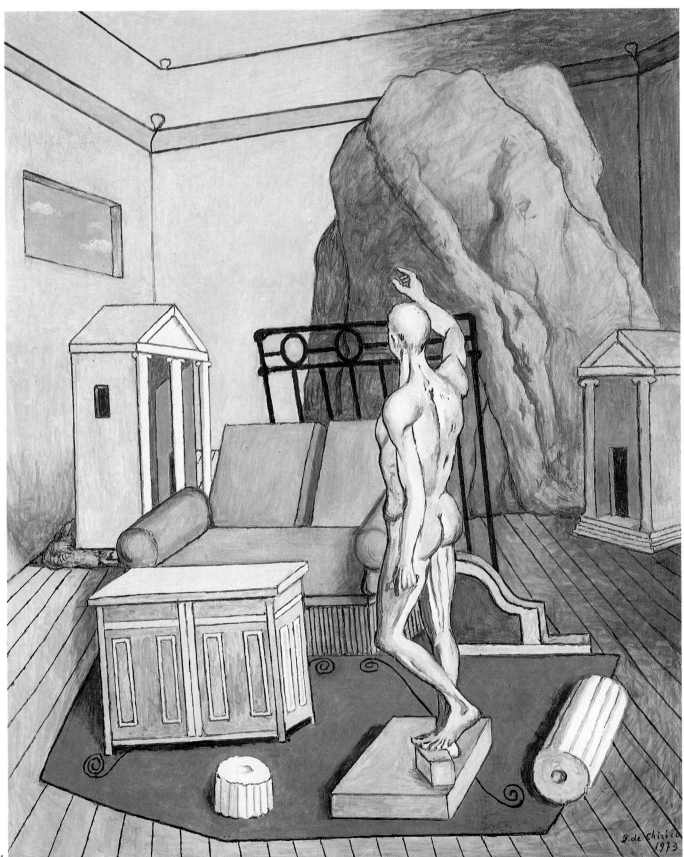

135. *The Great Metaphysician*. 1971.
Oil on canvas, $31\frac{1}{2} \times 23\frac{1}{2}$ in. $(80 \times 60$ cm).
Private Collection.

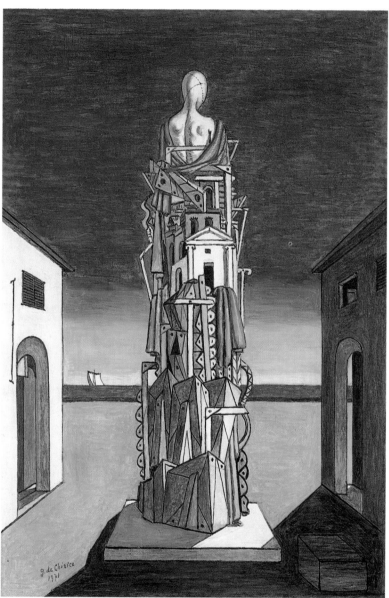

FONDAZIONE GIORGIO E ISA DE CHIRICO, ROME
(Isabella Pakszwer de Chirico Donation, 1986)

1. *Self-Portrait in the Nude.* 1945.
Oil on canvas, 22 × 16½ in. (56 × 42 cm).
(Fig. 85, color)

2. *The Astrologer.* 1950.
Oil on canvas, 21¼ × 17¾ in. (54 × 45 cm).

3. *Mythological Scene (after Rubens).* 1960.
Oil on canvas, 15¾ × 19¾ in. (40 × 50 cm).
(Fig. 79, color)

4. *The Prince's Toys.* 1960.
Oil on canvas, 21½ × 13¾ in. (55 × 35 cm).

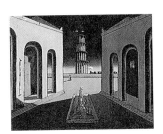

5. *Italian Square with Fountain.* 1960.
Oil on canvas, 15¾ × 19¾ in. (40 × 50 cm).

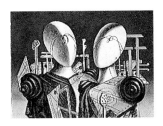

6. *Achilles' Horses.* 1965.
Oil on canvas, 31½ × 23½ in. (80 × 60 cm).

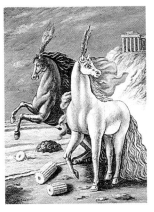

7. *Hector and Andromache.* 1970.
Oil on canvas, 12 × 15¾ in. (30 × 40 cm).

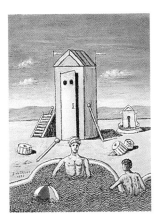

8. *Mysterious Baths.* 1973.
Oil on canvas, 25 × 18½ in. (63 × 47 cm).

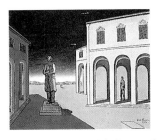

9. *Italian Square with Statue of Cavour.*
1974.
Oil on canvas, 19¾ × 23½ in. (50 × 60 cm).

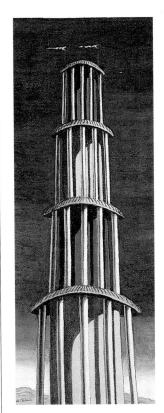

10. *The Tower.* 1974.
Oil on canvas, 36½ × 14 in. (93 × 35 cm).

The Isabella Pakszwer de Chirico Donation
at the Fondazione Giorgio e Isa de Chirico
is completed with a selection of graphic
works (100 lithographs and engravings).

GALLERIA NAZIONALE D'ARTE MODERNA, ROME
(Isabella Pakszwer de Chirico Donation, 1987)

1. *Portrait of the Artist's Mother*. 1911.
Oil on canvas, 33¾ × 24½ in. (85.5 × 62 cm).
Signed and dated at the bottom right:
"Giorgio de Chirico 1911." The work is
reproduced and commented upon in the
main monographs on the artist.
(Fig. 4, color.)

2. *The Pregnant Woman* (after Raphael).
1920.
Oil on board, 25½ × 19¼ in. (65 × 49 cm).
Signed at the top right:
"G. de Chirico da Raffaello." The work is
dated 1920 (*cf. L'Opera completa...*, 1984,
No. 154) or 1922 (*cf.* Far, *de Chirico*, 1968,
p. 18; *Catalogo generale...* I, 1, 1971, No. 51).
(Fig. 37, color.)

3. *Lucretia*. 1922.
Oil on canvas, 68½ × 30 in. (174 × 76 cm).
Signed and dated at the top right:
"G. de Chirico pinxit MCMXXII." The
work is reproduced and commented upon in
the main monographs on the artist.
(Fig. 39, color.)

4. *The Archaeologists*. 1927.
Oil on canvas, 45¾ × 35 in. (116 × 89 cm).
Signed and dated at the top right:
"G. de Chirico 1927." The work is widely
documented. It is dated 1928 in *Giorgio de
Chirico: Parigi 1924-1929*, 1982, No. 105.
(Fig. 50, color.)

5. *Diana Sleeping in the Wood*. 1933.
Oil on canvas, 35½ × 46 in. (90.5 × 117 cm).
Signed and dated at the bottom left:
"G. de Chirico 1933." The work appears in
the *Catalogo generale...* I, 2, 1973, No. 7,
and in *Conoscere de Chirico...*, 1979,
No. 168.
(Fig. 58, color.)

6. *Naked Woman on the Beach (Alcmena's
Repose)*. 1932.
Oil on canvas, 28 × 53¼ in. (71.5 × 135.5 cm).
Signed at the bottom right:
"G. de Chirico." The work is reproduced
unsigned in the catalogue of the one-man
exhibition at the Galleria Vitelli in Genova,
in 1933. The signature appears in the
reproduction in Far, *de Chirico*, 1968,
fig. 131, where the painting is dated 1933
(p. 20). By contrast, in the *Catalogo
generale...*, I, 2, 1971, No. 6, and in
Conoscere de Chirico..., 1979, No. 167,
it is dated 1932.
(Fig. 57, color.)

7. *The Master's Studio in Paris*. c. 1933-1934.
Oil on canvas, 11¾ × 15¾ in. (55.5 × 46.5 cm).
Signed at top right:
"G. de Chirico." The work is dated 1934
(*cf.* among others Far, *de Chirico*, 1968,
p. 19; *Catalogo generale...* I, 2, 1971,
No. 18; *Conoscere de Chirico*, 1979, No. 3),
1933 (*de Chirico néo-baroque*, Artcurial
Paris, 1985, No. 1) or 1934-1935 (*Giorgio de
Chirico*, Palazzo Reale, Milan, No. 106).
(Fig. 70, color.)

8. *Portrait of Isa in a Black Dress*. 1935.
Oil on canvas, 24¾ × 18¼ in. (100 × 80.5 cm).
Signed and dated on the right:
"G. de Chirico 1935." The work has been
reproduced on numerous occasions.
(Fig. 69, color.)

9. *Self-Portrait in the Paris Studio*. 1935.
Oil on canvas, 50 × 30 in. (130 × 76 cm).
Signed "G. de Chirico" on the right and
signed for the second time at the bottom
right, "G. de Chirico 1935." The second
inscription does not appear in the
reproduction in Far, *de Chirico*, 1968, fig. 74,
where the painting is dated 1934 (p. 19). The
signature appears in the catalogue for the
exhibition at the Palazzo Reale of Milan in
1970 (No. 107), in which the work is
similarly dated 1934, as it is in all
subsequent bibliography, with the exception
of a few authors who date it 1935. The
painting was presented at the Rome
Quatrennial in 1935.
(Fig. 68, color.)

10. *Self-Portrait in the Nude*. 1945
(or 1942).
Oil on canvas, 24 × 19¾ in. (60.5 × 50 cm).
Signed and dated at the top right:
"G. de Chirico 1945." The date does not
appear in the reproduction in Far, *de
Chirico*, 1968, fig. 140, in which the
painting is dated 1942 (p. 20). In subsequent
bibliography it is dated 1942, 1942-1943 or
1945. Initially the figure was completely
naked and the work was reproduced thus in
the catalogue for the one-man exhibition in
1945 at the Galleria del Secolo, Rome; the
loincloth was added for the exhibition at the
Royal Society Academy in London, in 1949
(*cf.* cat. GNAM, II, 1981, pp. 43, 45).
(Fig. 84, color.)

11. *Self-portrait in Seventeenth-Century
Costume*. 1947.
Oil on canvas, 32¼ × 23¼ in. (82.5 × 59 cm).
Signed and dated at the bottom right:
"G. de Chirico 1947." The date does not
appear in the reproduction in Far, *de
Chirico*, 1968, fig. 167, where the painting is
dated 1949 (p. 20). In subsequent
bibliography the painting is dated,
depending on each individual author, 1947,
1949 or 1952. The painting has been
identified as the one presented in 1949 at the
one-man exhibition in London (*cf.* cat.
GNAM, I, 1981, p. 126).
(Fig. 93, color.)

12. *Self-Portrait in Black Costume*. 1948.
Oil on canvas, 60 × 35¼ in. (152.5 × 89.5 cm).
Signed and dated at the bottom left:
"G. de Chirico 1948." The date does not
appear in the reproduction in Far, *de
Chirico*, 1968, fig. 133, where the painting is
dated 1953. In subsequent bibliography it is
dated 1948. The work was exhibited at the
Venice Biennial in 1956.
(Fig. 105, color.)

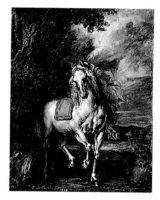

13. *White Horse in the Wood (Arion)*. 1948.
Oil on canvas, 19¾ × 15¾ in. (50 × 40 cm).
Signed and dated at the bottom left:
"G. de Chirico 1948." The date does not
appear in the reproduction in Far, *de
Chirico*, 1968, fig. 70, where the painting is
dated 1957 (p. 19). In subsequent
bibliography it is dated 1948 or 1958.

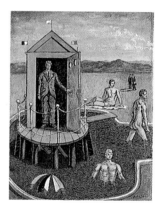

14. *The Mysterious Baths*. 1938 (or 1966?).
Oil on canvas, 25½ × 19¾ in. (65 × 50 cm).
Signed at the bottom right:
"G. de Chirico." The work is dated 1966 in
Far, *de Chirico*, 1968, p. 18, and 1938 in the
catalogue for the exhibition *G. de Chirico* at
the Musée Marmottan in Paris i 1975 (No.
9). The iconography is taken from a 1934
lithograph.

15. *The Disturbing Muses*. 1925.
Oil on canvas, 38 × 26½ in. (97 × 67 cm).
Signed and dated at the bottom left:
"G. de Chirico 1925." The work appears
with this date in the catalogue for the
exhibition *I de Chirico di de Chirico*
(Ferrara, 1970, No. 16) and in the
subsequent North American and Japanese
exhibitions with the same title (Art Gallery
of Ontario, 1972, No. 2; Kamakura-Kyoto-
Nagoya, 1973-1974, No. 2), as well as in the
catalogue for the exhibition *G. de Chirico* at
the Musée Marmottan, Paris, 1975, No. 4.
The work does not figure, however, in
Giorgio de Chirico: Parigi 1924-1929, 1982.
(Fig. 44, color.)

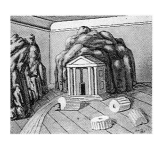

16. *The Temple in the Room.* 1927.
Oil and tempera on canvas,
19¾ × 24 in. (50 × 61 cm).
Signed and dated at the bottom right:
"G. de Chirico 1927." The date (which
seems to have been added later, since the
handwriting is different from that of the
signature) appears in the reproduction in
Far, *de Chirico*, 1968, fig. 129. The work,
dated 1927 even in the catalogue for the
exhibition *De Chirico by de Chirico* (Art
Gallery of Ontario, 1972, No. 31), does not
however figure in *Giorgio de Chirico: Parigi
1924-1929*, 1982.

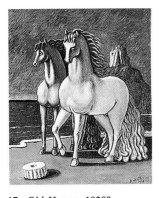

17. *Old Horses.* 1928?
Oil and tempera on canvas,
23½ × 19¾ in. (60 × 50 cm).
Signed and dated at the bottom right:
"G. de Chirico 1928." The handwriting for
the date is different from that of the
signature, so it seems that the date was
added later. The work (which does not
figure in *Giorgio de Chirico: Parigi
1924-1929*, 1982) is reproduced in the
catalogue for the one-man exhibition at the
Galerie Isy Brachot, Brussels (1976).
A lithograph of 1974 contains the same
iconography as the painting.

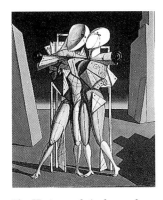

18. *Hector and Andromache.*
Oil on canvas, 23½ × 19¾ in. (60 × 50 cm).
Signed and dated at the bottom right:
"G. de Chirico 1931."

19. *Gladiators.* 1932.
Oil on canvas, 23½ × 19¾ in. (60 × 50 cm).
Signed at the bottom right:
"G. de Chirico 1932."
The date does not appear in the
reproduction in Far, *de Chirico*, 1968,
fig. 150, where the painting is dated 1958
(p. 20). In subsequent bibliography it is
dated either 1932 or 1933.
(Fig. 62, color.)

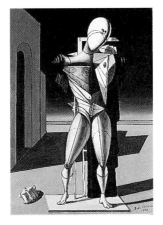

20. *The Troubadour.* 1932.
Oil on canvas, 25½ × 18 in. (65 × 46 cm).
Signed and dated at the bottom right:
"G. de Chirico 1932."

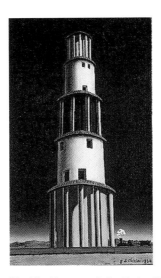

21. *The Tower and the Train.* 1934.
Oil on canvas, 21½ × 13 in. (55 × 33 cm).
Signed and dated at the bottom right:
"G. de Chirico 1934."

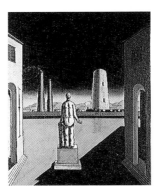

22. *Present and Past.* 1936.
Oil on canvas, 23½ × 19¾ in. (60 × 50 cm).

Signed and dated at the bottom right:
"G. de Chirico 1936." The work appears
reproduced in the catalogue for the one-man
exhibition held at the Galleria Ca' d'Oro, Rome,
1974 (No. 12).

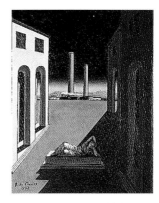

23. *Italian Square.* 1937.
Oil on canvas, 19¾ × 15¾ in. (50 × 40 cm).
Signed and dated at the bottom left:
"G. de Chirico 1937." The work was
reproduced in the catalogue for the one-man
exhibition held in 1976 at the Wildenstein
Gallery in London, with the title
L'Enchantement du Silence (The Charm of
Silence), No. 2.

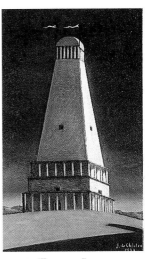

24. *The Tower of Silence.* 1937.
Oil on canvas, 22 × 13½ in. 56 × 34 cm).
Signed and dated at the bottom right:
"G. de Chirico 1937."

The data has been taken from the archives
complied by the Galleria Nazionale d'Arte
Moderna, Rome, in the catalogue with a
foreword by Augusta Monferini,
superintendent of the GNAM.

LIST OF ILLUSTRATIONS

48. *The Painter's Family*. 1926.
Oil on canvas, 57¾ × 45¼ in.
(146.5 × 115 cm).
Tate Gallery, London.

49. *Interview*. 1927.
Oil on canvas, 51¼ × 38¼ in. (130 × 97 cm).
National Gallery, Washington.
Chester Dale Collection.

50. *The Archaeologists*. 1927.
Oil on canvas, 45¾ × 35 in. (116 × 89 cm).
Galleria Nazionale d'Arte Moderna, Rome.
Isabella Pakszwer de Chirico Donation.

51. *The Shores of Thessaly*. 1926.
Oil on canvas, 36¼ × 28¾ in. (92 × 73 cm).
Private Collection.

52. *Furniture in the Valley*. 1927.
Oil on canvas, 51¼ × 38¼ in. (130 × 97 cm).
Private Collection, Rome.

53. *Gladiators*. 1928.
Oil on canvas, 63 × 37½ in. (160 × 95 cm).
Private Collection, Rome.

54. *Still Life*. 1929.
Oil on canvas, 28¾ × 39¾ in. (73 × 101 cm).
Galleria Nazionale d'Arte Moderna, Rome.

55. *Little Oriental Head*. 1929.
Oil on canvas, 15¾ × 11¾ in. (40 × 30 cm).
Private Collection, Trieste.

56. *Nude Woman*. 1929.
Oil on canvas, 35¾ × 29 in. (91 × 74 cm).
Antonio Russo Collection, Rome.

57. *Naked Woman on the Beach* (The Repose of Alcmena). 1932.
Oil on canvas, 28 × 53¼ in. (71.5 × 135.5 cm).
Galleria Nazionale d'Arte Moderna, Rome.
Isabella Pakszwer de Chirico Donation.

58. *Diana Sleeping in the Wood*. 1933.
Oil on canvas, 35½ × 46 in. (90.5 × 117 cm).
Galleria Nazionale d'Arte Moderna, Rome.
Isabella Pakszwer de Chirico Donation.

59. *Portrait of Isa*. 1933.
Oil on canvas, 17¼ × 14½ in. (44 × 37 cm).
Private Collection, Rome.

60. *Bathers on the Beach*. 1934.
Oil on canvas, 43¼ × 59 in. (110 × 150 cm).
Private Collection, Rome.

61. *Amazon*. 1934.
Oil on canvased cardboard, 23½ × 19¾ in.
(60 × 50 cm).
Private Collection, Rome.

62. *Gladiators*. 1932.
Oil on canvas, 23½ × 19¾ in. (60 × 50 cm).
Galleria Nazionale d'Arte Moderna, Rome.
Isabella Pakszwer de Chirico Donation.

63. *Changing Huts*. 1935.
Oil on canvas, 19¾ × 15¾ in. (50 × 40 cm).
Private Collection, Rome.

64. *Genova Landscape*. 1933.
Oil on canvas, 21 × 26 in. (53 × 66 cm).
Private Collection, Rome.

65. *Landscape with Divinity*. 1936.
Oil on canvas, 17¼ × 14½ in. (44 × 37 cm).
Private Collection, Rome.

66. *The Turk*. 1935.
Oil on canvas, 15 × 17¾ in. (38 × 45 cm).
Private Collection, Rome.

67. *The Cascine Landscape*. 1934.
Oil on canvas, 22 × 14½ in. (56 × 37 cm).
Private Collection, Rome.

68. *Self-Portrait in the Paris Studio*. 1935.
Oil on canvas, 51¼ × 30 in. (130 × 76 cm).
Galleria Nazionale d'Arte Moderna, Rome.
Isabella Pakszwer de Chirico Donation.

69. *Portrait of Isa in a Black Dress*. 1935.
Oil on canvas, 39½ × 31¾ in. (100 × 80.5 cm).
Galleria Nazionale d'Arte Moderna, Rome.
Isabella Pakszwer de Chirico Donation.

70. *The Master's Studio in Paris*.
c. 1933-1934.
Oil on canvas, 21¾ × 18¼ in.
(55.5 × 46.5 cm).
Galleria Nazionale d'Arte Moderna, Rome.
Isabella Pakszwer de Chirico Donation.

71. *Italian Square with Equestrian Statue*.
1936.
Oil on canvas, 23½ × 19¾ in. (60 × 50 cm).
Private Collection, Rome.

72. *Horseman with Red Cap and Blue Cape*.
1939.
Oil on paper on cardboard, 18 × 15 in.
(46 × 38 cm).
Galleria Nazionale d'Arte Moderna, Rome.

73. *The Horse of the Missing Rider*. 1938.
Oil on canvas, 35 × 38½ in. (89 × 98 cm).
Private Collection, Rome.

74. *Fallen Horse*. 1941.
Oil on canvas, 21 × 18 in. (53 × 46 cm).
Private Collection, Rome.

75. *Portrait of a Man (after Titian)*. 1945.
Oil on canvas, 12¼ × 9 in. (31 × 23 cm).
Private Collection, Rome.

76. *Head of Old Man (after Fragonard)*.
c. 1964.
Oil on canvas, 19¾ × 15¾ in. (50 × 40 cm).
Private Collection, Rome.

77. *Sleeping Girl (after Watteau)*. 1947.
Oil on canvas, 15¾ × 19¾ in. (40 × 50 cm).
Private Collection, Rome.

78. *Nymph with Triton (after Rubens)*. 1942.
Oil on canvas, 15¾ × 19¾ in. (40 × 50 cm).
Private Collection, Rome.

79. *Mythological Scene (after Rubens)*. 1960.
Oil on canvas, 15¾ × 19¾ in. (40 × 50 cm).
Fondazione Giorgio e Isa de Chirico, Rome.
Isabella Pakszwer de Chirico Donation.

80. *Phaeton's Fall (after Rubens)*. 1954.
Oil on canvas, 19¾ × 15¼ in. (50 × 40 cm).
Private Collection, Rome.

81. *Portrait of Isa with Rose in the Park*.
1938.
Oil on canvas, 42½ × 33½ in. (108 × 85 cm).
Private Collection, Rome.

82. *The Colonial Dummies*. 1943.
Oil on canvas, 32¾ × 21 in. (83 × 53 cm).
Private Collection.

83. *Italian Square with Red Tower*. 1943.
Oil on canvas, 19¾ × 15¾ in. (50 × 40 cm).
Private Collection, Rome.

84. *Self-Portrait in the Nude*. 1945 (or 1942).
Oil on canvas, 23¾ × 19¾ in. (60.5 × 50 cm).
Galleria Nazionale d'Arte Moderna, Rome.
Isabella Pakszwer de Chirico Donation.

85. *Self-Portrait in the Nude*. 1945.
Oil on canvas, 22 × 16½ in. (56 × 42 cm).
Fondazione Giorgio e Isa de Chirico, Rome.
Isabella Pakszwer de Chirico Donation.

86. *Landscape with Village*. *c*. 1940.
Oil on canvas, 13½ × 21½ in. (35 × 55 cm).
Private Collection, Rome.

87. *Villa Falconieri*. 1946.
Oil on canvas, 15¾ × 19¾ in. (40 × 50 cm).
Private Collection, Rome.

88. *Villa Medici: Pavilion with Statue*. 1945.
Oil on canvas, 23½ × 17¼ in. (60 × 44 cm).
Private Collection, Rome.

89. *Still Life with Rocky Landscape*. 1942.
Oil on canvas, 14¼ × 17¾ in. (36 × 45 cm).
Private Collection, Rome.

90. *Black Grape (Still Life with Landscape)*.
1947.
Oil on canvas, 15¾ × 19¾ in. (40 × 50 cm).
Private Collection, Rome.

91. *Silent Life with Venetian Landscape*.
c. 1952.
Oil on canvas, 19¾ × 23½ in. (50 × 60 cm).
Private Collection, Rome.

92. *Bust of Minerva*. 1947.
Oil on canvas, 23½ × 19¾ in. (60 × 50 cm).
Private Collection, Rome.

93. *Self-Portrait in Seventeenth-Century
Costume*. 1947.
Oil on canvas, 32½ × 23¼ in. (82.5 × 59 cm).
Galleria Nazionale d'Arte Moderna, Rome.
Isabella Pakszwer de Chirico Donation.

94. *Self-Portrait*. 1948.
Oil on canvas, 15¾ × 11¾ in. (40 × 30 cm).
Private Collection.

95. *Self-Portrait*. 1949.
Oil on canvas, 7¾ × 5½ in. (19.5 × 14 cm).
Private Collection, Trieste.

96. *Castor and his Horse*. 1947.
Oil on canvas, 24 × 31 in. (61 × 79 cm).
Private Collection, Rome.

97. *Horses with Temple*. 1949.
Oil on canvas, 19 × 22¾ in. (48 × 58 cm).
Private Collection.

98. *Dioscurus and Horse*. 1949.
Oil on canvas, 24 × 31 in. (61 × 79 cm).
Private Collection, Rome.

99. *The Fall. c.* 1947-1954.
Oil on canvas, 72¾ × 63 in. (185 × 160 cm).
Private Collection, Rome.

100. *The Tournament*. 1952.
Oil on canvas, 23½ × 31½ in. (60 × 80 cm).
Private Collection, Rome.

101. *Hector and Andromache*. 1946.
Oil on canvas, 32¼ × 23½ in. (82 × 60 cm).
Private Collection, Rome.

102. *Metaphysical Interior with Workshop*.
1948.
Oil on canvas, 25½ × 21 in. (64.5 × 53.5 cm).
Private Collection, Rome.

103. *The Italian Beauty*. 1952.
Oil on canvas, 34½ × 31½ in. (88 × 80 cm).
Private Collection, Rome.

104. *Naiads Bathing*. 1955.
Oil on canvas, 32¼ × 42½ in. (82 × 108 cm).
Private Collection, Rome.

105. *Self-Portrait in Black Costume*. 1948.
Oil on canvas, 60 × 35¼ in. (152.5 × 89.5 cm).
Galleria Nazionale d'Arte Moderna, Rome.
Isabella Pakszwer de Chirico Donation.

106. *Self-Portrait in Seventeenth-Century
Costume* (or *Self-Portrait in a Park*). 1959.
Oil on canvas, 60¼ × 38½ in. (153 × 98 cm).
Private Collection, Rome.

107. *Cake with Silver Teapot. c.* 1952.
Oil on canvas, 19¾ × 23½ in. (50 × 60 cm).
Private Collection, Trieste.

108. *Silver Objects* or *Silent Still Life with
Silver Crockery*. 1962.
Oil on canvas, 54¼ × 76 in. (138 × 193 cm).
Private Collection.

109. *Gladiators' School*. 1953.
Oil on canvas, 39½ × 31½ in. (100 × 80 cm).
Private Collection, Rome.

110. *He who Comforts. c.* 1960.
Oil on canvas, 39½ × 32 in. (100 × 81 cm).
Private Collection, Rome.

111. *The Via Appia. c.* 1954.
Oil on canvas, 17 × 21¼ in. (43 × 54 cm).
Private Collection, Rome.

112. *Florence: The Arno*. 1957.
Oil on canvas, 17 × 21¼ in. (43 × 54 cm).
Private Collection, Rome.

113. *St George's Island*. 1957.
Oil on canvas, 19¼ × 22¾ in. (49 × 58 cm).
Private Collection, Rome.

114. *Metaphysical Interior with Biscuits*.
1958.
Oil on canvas, 25½ × 19¾ in. (65 × 50 cm).
Private Collection, Rome.

115. *The Red Glove*. 1958.
Oil on canvas, 28¼ × 19 in. (72 × 48 cm).
Private Collection, Rome.

116. *Flowers in a Copper Pot*. 1960-1968.
Oil on canvas, 35½ × 31½ in. (90 × 80 cm).
Private Collection, Rome.

117. *Island with a Garland of Flowers*. 1969.
Oil on cardboard, 19¾ × 23½ in. (50 × 60 cm).
Private Collection, Rome.

118. *Self-Portrait with Palette*. 1960.
Oil on cardboard, 17¾ × 11¾ in. (45 × 30 cm).
Private Collection, Rome.

119. *Horsemen and Horses by the Sea.
c.* 1960.
Oil on canvas, 30 × 42 in. (76 × 107 cm).
Private Collection, Rome.

120. *Head of White Horse with Mane
Blowing in the Wind*. 1959.
Oil on canvas, 19¾ × 15¾ in. (50 × 40 cm).
Private Collection, Rome.

121. *Country Scene with Landscape. c.* 1960.
Oil on canvas, 42 × 30 in. (107 × 76 cm).
Private Collection, Rome.

122. *The Divine Horses of Achilles: Balios
and Xanthos*. 1963.
Oil on canvas, 38½ × 34½ in. (98 × 87 cm).
Private Collection, Rome.

123. *The Intruder. c.* 1970.
Oil on canvas, 15¼ × 19¾ in. (40 × 50 cm).
Private Collection, Rome.

124. *Apollo's Horses*. 1974.
Oil on canvas, 36½ × 28¾ in. (92.5 × 73 cm).
Private Collection, Rome.

125. *Ulysses' Return*. 1968.
Oil on canvas, 23½ × 31½ in. (60 × 80 cm).
Private Collection, Rome.

126. *Mysterious Baths. Flight to the Sea.*
1968.
Oil on canvas, 31½ × 23½ in. (80 × 60 cm).
Private Collection, Rome.

127. *Metaphysical Interior with Setting Sun.*
1971.
Oil on canvas, 31½ × 23½ in. (80 × 60 cm).
Private Collection, Rome.

128. *Sun Rising over the Square*. 1971.
Oil on canvas, 19¾ × 27½ in. (50 × 70 cm).
Private Collection, Rome.

129. *Italian Square with Monument to the
Poet)*. 1969.
Oil on canvas, 31½ × 23½ in. (80 × 60 cm).
Private Collection, Rome.

130. *The Great Game (Italian Square)*. 1971.
Oil on canvas, 23½ × 31½ in. (60 × 80 cm).
Private Collection, Paris.

131. *The Dioscuri*. 1974.
Oil on canvas, 35¾ × 28¼ in. (91 × 72 cm).
Private Collection, Paris.

132. *The Masks*. 1974.
Oil on canvas, 23½ × 19¾ in. (60 × 50 cm).
Private Collection, Rome.

133. *The Muse of Silence*. 1973.
Oil on canvas, 36¼ × 28¾ in. (92 × 73 cm).
Private Collection, Rome.

134. *Furniture and Rocks in a Room*. 1973.
Oil on canvas, 39½ × 32 in. (100 × 81 cm).
Private Collection, Rome.

135. *The Great Metaphysician*. 1971.
Oil on canvas, 31½ × 23½ in. (80 × 60 cm).
Private Collection.

FONDAZIONE GIORGIO E ISA DE
CHIRICO, ROME
(Isabella Pakszwer de Chirico Donation,
1986)
Page 123

GALLERIA NAZIONALE D'ARTE
MODERNA, ROME
(Isabella Pakszwer de Chirico Donation,
1987)
Pages 124-125